SENSE OF HOME

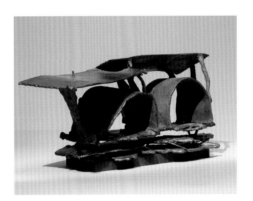

This book is published in conjunction
with the Houston Artists Fund

NUMBER NINETEEN
Joe and Betty Moore Texas Art Series

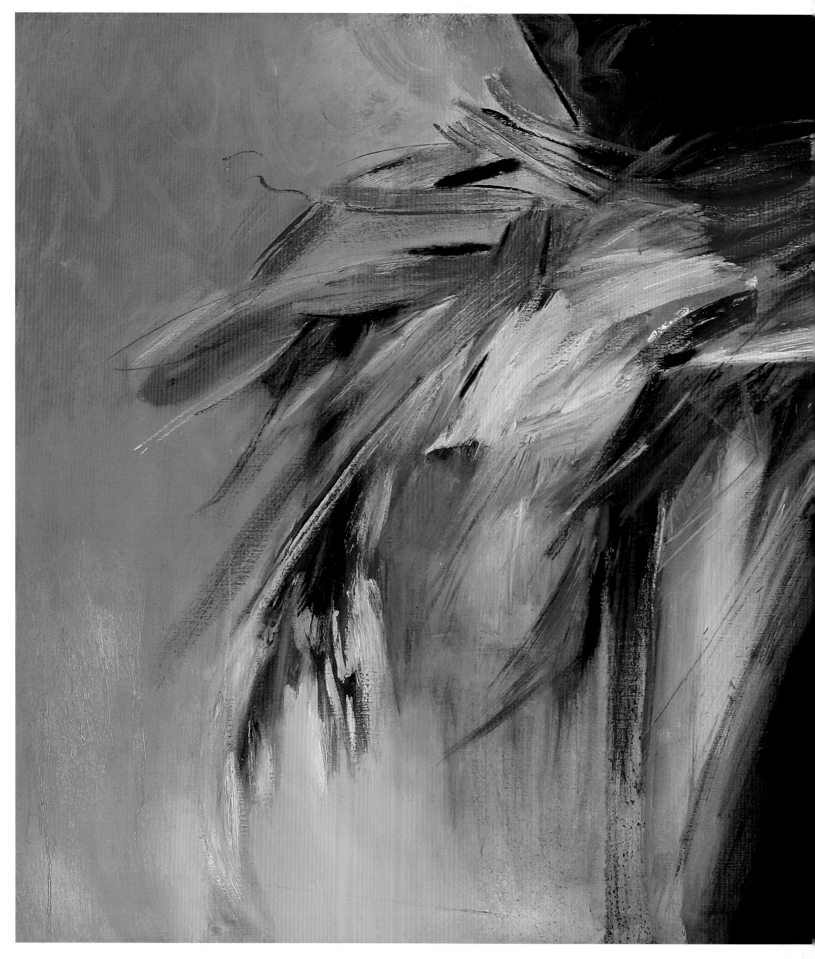

SENSE OF HOME
The Art of Richard Stout

EDITED BY WILLIAM E. REAVES & LINDA J. REAVES

With Contributions by
Katie Robinson Edwards, David E. Brauer,
Jim Edwards, Sarah Beth Wilson,
and Mark White

TEXAS A&M UNIVERSITY PRESS ■ COLLEGE STATION

This paper meets the requirements
of ANSI/NISO Z39.48–1992 (Permanence of Paper).
Binding materials have been chosen for durability.
Manufactured in China by Everbest Printing Co.
through FCI Print Group

LIBRARY OF CONGRESS CATALOGING-IN-PUBLICATION DATA

Names: Reaves, William E., editor. | Reaves, Linda J., editor. | Edwards,
 Katie Robinson, 1964– contributor.
Title: Sense of home: the art of Richard Stout / edited by William E. and
 Linda J. Reaves; with contributions by Katie Robinson Edwards, David E.
 Brauer, Jim Edwards, Sarah Beth Wilson, and Mark White.
Other titles: Joe and Betty Moore Texas art series; no. 19.
Description: First edition. | College Station: Texas A&M University Press,
 [2017] | Series: Joe and Betty Moore series in Texas art; number nineteen
 | Includes bibliographical references and index.
Identifiers: LCCN 2017007154 | ISBN 9781623495701 (alk. paper)
Subjects: LCSH: Stout, Richard, 1934– | Artists—Texas—Biography. | Home
 in art. | Texas—In art.
Classification: LCC N6537.S772 S46 2017 | DDC 700.92 [B] —dc23 LC
 record available at https://lccn.loc.gov/2017007154

CONTENTS

ACKNOWLEDGMENTS

In the production of any book many individuals and institutions make important contributions. It is my privilege to acknowledge and recognize those key players for this publication and convey my genuine regard for their stellar efforts on behalf of the entire project.

I thank my business partner and professional colleague, Sarah Foltz. Sarah has served as co–project director for the Richard Stout Project, and in this capacity she has worked tirelessly to help secure the necessary funds, organize and disseminate images of the artist's works, and provide the innumerable forms of editorial assistance and support to make the project work. I am deeply grateful for her capable and enthusiastic support.

Of course, this book would not be possible without the contributing essayists, all of whom have written authoritatively about Stout's magnificent output, lending interesting and poignant insight into his work. These accomplished art scholars, David Brauer, Jim Edwards, Katie Robinson Edwards, Mark White, and Sarah Beth Wilson, have combined efforts to produce the definitive publication on the art of Richard Stout. It was a pleasure to have worked with such a distinguished group, and I am honored that they would lend their considerable knowledge and expertise to this endeavor.

The images that accompany and illuminate their essays were generously lent by many devoted collectors of Richard Stout's paintings and sculpture, and we extend a special thanks to these lenders, all of whom are referenced herein, for granting us the opportunity to publish and share these magnificent artworks.

Several important institutions have partnered with us in the development of this book, as well as the accompanying retrospective exhibition, and we are grateful for their support and contributions. Shannon Davies, executive director; Thom Lemmons, senior editor; and the entire staff of Texas A&M University Press have worked diligently to design, edit, and publish a lovely book. I am grateful for their guidance, oversight, and publishing expertise. Likewise, Lynn Castle, director, and Sarah Beth Wilson, curator of the Art Museum of Southeast Texas, have supplied sound curatorial and administrative leadership to enable the associated retrospective exhibition to come to fruition.

The project could not have moved forward without adequate financial support; thus, I am especially grateful to those individuals and institutions who generously contributed funds to this effort, as well as to Jody Blazek and the Board of the Houston Artists Fund, who supplied expert accounting and financial assistance in their role as fiscal agent for the project. Specific donors are recognized in the front of this

book, and we thank all for their gifts in support of the project.

Greatest thanks, however, go to my wife, partner, and colleague, Linda Reaves, for her myriad contributions to this entire project. Linda compiled the complete biographical profile of the artist, as well as skillful and informed editorial assistance at every stage of production. As a devotee of both the editor and the artist, Linda offered a wonderful mix of encouragement, organization, and hands-on support to make certain that work was completed on time and in good order. I am indebted in so many ways for her partnership in this and all other ventures of my life.

Finally, on behalf of all involved, I convey our special regard and appreciation for the artist, Richard Stout. It is because of him and his inspired artistic vision that so many of the people mentioned here have so willingly contributed their time, resources, and expertise to document and share his amazing journey. We are grateful for his presence in our lives and for his inspirational work over a lifetime of art. It is our hope that this book serves as a fitting tribute to his full and worthy career.

WILLIAM E. REAVES

We gratefully acknowledge the following donors whose generous gifts made publication possible:

Principal Sponsors

Cynthia and Bill Gayden
H. Russell Pitman
Penn and Margarida Williamson
The Trull Foundation
Center for the Advancement and Study of Early Texas Art (CASETA)
William Reaves | Sarah Foltz Fine Art
Estate of Dick Wray

Sponsors

Jason Aigner and Mrs. Mary
 Aigner
Judy and Stephen Alton
Sharmila Anandasabapathy
 and Andrew Sikora
Jeff Beauchamp
Minnette and Peter Boesel
Lenni and Bill Burke
Bill and Ginny Camfield
Bonnie Campbell
David Cargill
Bettie Cartwright
Duncan Corbett
Gayle and Mike DeGuerin
Jan M. Diesel

David Ellis
Sally and Steve Gaskin
Peter Gershon
Mark and Geralyn Kever
Tom and Tam Kiehnhoff
Tamara and Richard King
Dee Kreft, Gayle and Michael
 Collins
Chongok Lee Matthews /
 P. McGowan Johnson
Bobbie and John Nau
Marilyn Oshman
Noe and Kim Perez
Charles M. Peveto
Stan Price and Clay Huffard

Sally and Norman Reynolds
Rick and Nancy Rome
Barry and Judy Rose
Kay L. Sheffield
Jeff Sone
Lias J. Steen
Randy Tibbits and Rick
 Bebermeyer
Renée Wallace
Earl Weed and Dorothy King
Jill and Mike Wentworth
Hayden and Johanna Winkler
Robert and Lauri Wray

INTRODUCTION

William E. Reaves

As a longtime collector of Texas art and now a dealer in the same field, I have been privileged to know and work with many accomplished Texas artists. I have derived much inspiration from each of these relationships, and my admiration for these artists and their work runs deep. No artist, however, has inspired me more than Richard Stout.

On a personal level, Stout affected me immediately through his paintings, especially his poetic and sensitive expressions of the Texas coast. It is a part of the country in which we both grew up and for which we both share deep and obvious appreciation. It is a part of the country that Richard Stout interprets masterfully in his art, painting the Gulf and its endless bays and estuaries with perhaps greater frequency, acuity, and sensitivity than any other artist of his lifetime. For me, and I suspect for anyone who has ever maintained a serious, long-term relationship with the Texas coast, Stout absolutely captures its light, color, atmosphere, mood, and mystery, and he does so with unparalleled fidelity and regard. I am moved by these coastal paintings, imbued as they are with rich colors and tonalities and teeming with internal narratives that are at once both personal and universal.

On a professional level, Stout's thoughtful personage and magnificent works of art have served to ele-vate my own understandings of the ongoing plight of Texas artists, making me more aware of and sensitive to the qualities of their work, especially the works of artists who choose to convey their artistic visions in more abstract modes. To this end, the times spent and moments engaged with Richard Stout and his remarkable works have always been worthwhile and memorable for me.

Over the years, through innumerable visits to his studio, as well as frequent "sit-downs" at the gallery, I have gained substantial insight into the profound vision and meticulous creative process behind Stout's work. I have had the special privilege of observing him tease color, form, and affect from the canvases at his easel and tracking the progressive developments of his masterful paintings. He has afforded unbridled access to his extensive inventory of work, which I have explored often, receiving the benefit of his personal interpretations as well as his own strident critiques of these remarkable creations. I have sat beside him, as he opens the eyes of patrons with his nuanced insights into works on view, and participated in lively dialogues wherein he has recounted the ups and downs of coming of age as an artist in midcentury Houston. I have received so much from these special encounters, and I have never ceased to be amazed by his sensitive

perspective and visual fluency. He is, to my mind, the consummate professional, highly capable, uncompromising with both himself and others, and thoroughly devoted to the cause of art.

Stout is among the last of an important cadre of midcentury modernists who led Houston and the state into modes of abstract expressionism. Now working in his eighth decade, he has outlived noteworthy peers such as Jack Boynton, Dorothy Hood, and Dick Wray, with whom he shared common zeal and purpose as early abstract painters. As an artist, Stout has worked diligently and continuously since his arrival in Houston in 1957, manifesting a standard of excellence in his output that continues to this day. While Stout has achieved a fair share of acclaim over a life well lived, his long record of accomplishment and consistent quality of work have long merited careful documentation and serious analysis.

Through this book and an associated retrospective exhibition, Stout's rich and worthy oeuvre is finally addressed in its whole by five of the leading art scholars in the American Southwest.

Katie Robinson Edwards, the state's foremost authority on Lone Star modernism, introduces the story of Richard Stout by aptly recounting his eventful launch on the nascent Houston arts scene, tracing key developments of his early career and assessing the evolution of his style during this critical formative period. David Brauer, the longtime art historian at the Museum of Fine Arts, Houston's Glassell School of Art joins where Robinson Edwards ends. He extends the artist's story with commentary and poignant observations on the transient qualities of Stout's work on interior subjects, an important element of the artist's work during the latter twentieth and early twenty-first centuries. Art critic and professor Jim Edwards follows with the first complete examination of Stout's three-dimensional works, calling long overdue attention to the artist's important sculptural contributions and addressing the artful interaction and synergistic connectivity between Stout's incredible abstract paintings and his distinctive found-object sculpture. Curator Sarah Beth Wilson of the Art Museum of Southeast Texas, one of the state's rising young art professionals, brilliantly explores the artist's work from the later twentieth century to the present, illuminating this hallmark period of Stout's work with both personal and professional sentiment. Finally, Mark White, director of the University of Oklahoma's Jones Museum, anchors the sequence with sterling analysis of Stout's career and artistic contributions within the larger regional context of abstract expressionism, offering insights on Stout's broader influence and import as a modernist leader in the American Southwest.

These outstanding essays are complemented by more than sixty color images of Stout's exemplary works organized by Sarah Foltz and biographical notes by Linda Reaves, both project co-directors and principals at William Reaves | Sarah Foltz Fine Art. Together these authors and researchers offer a complete and definitive account of one of Texas' most important modernist artists.

BOUND TO THE SEA

Katie Robinson Edwards

The emblem of the cosmopolitan modernist artist, Richard Stout is a native Texan. He has been making art virtually his entire life, producing thousands of paintings, sculptures, and works on paper.[1] Over the years Stout had made consistently high-caliber work, remaining true to his themes and interests, expanding and exploring them. Regularly producing superlative work over a long career would be laudable enough, but Stout matches his skill with in-depth investigations of profound material. As the new millennium approached, Stout was in his sixties. Rather than wane, his work "entered an area of excellence that is both startling and engrossing," wrote the philosopher-scholar Thomas McEvilley.[2] Still today Stout continues to surprise and delight with new paintings and drawings that incorporate sculptural elements in moving ways.

Through his thousands of two-dimensional paintings and drawings, Stout has mastered seascapes, architectural interiors, and surreal combinations of both. He often punctures the picture plane visually, teasing out a third dimension. (More on that follows; see also Jim Edwards's essay on Stout's sculpture in this book.) Critics and interpreters of his art find a variety of adjectives to describe his particular form of expressionism: eloquent, emotional, evocative, haunted, penetrating, mysterious, profound, sublime.

"In truth, there is no more sophisticated painter working in the Southwest," wrote Ted Pillsbury in 2001.[3] Although it would be a foolhardy attempt to sum up such a career in a short essay, notable characteristics anchor Stout's work. Despite the emotional intensity of many paintings and the universal aspect of his scenes, many of his prime expressionist works revolve around his close identification with the Texas coast.

Stout's longtime connectivity to the Gulf and his use of this framework as a means of expression are unique among twentieth-century Southern abstract artists.[4] Generally his modernist Texas peers turned increasingly toward abstraction—Forrest Bess (1911–1977), Dorothy Hood (1919–2000), Toni LaSelle (1901–2002), Robert Preusser (1911–1992), and Dick Wray (1933–2011)—or made forays into pop art—Jack Boynton (1928–2010) and Jim Love (1927–2005). Stout, too, embarked on a series of geometric symmetrical paintings in the late 1960s and 1970s that exude a pop aesthetic, but he would always return to the overt influence of the Gulf. Stout's work has always been anchored to the coast, returning to it again and again as a perpetual source.

Tellingly, Stout was raised in Beaumont. He left for college in the Midwest when he was sixteen. Those early coastal years proved crucial. From a very

young age, Stout was cognizant of the ocean's formidable quality. According to the Austrian art historian and scholar Konrad Oberhuber (1935–2007), an artist's visual vocabulary is formed by the place where he or she spends the first seven years[5]—that is, from birth to seven years, even before the artist answers to his or her calling. As Stout matured artistically and psychologically, the metaphor of the sea became more compelling and more relevant. He seems to have returned to the coast repeatedly during the years to find his bearings and convey his moods and expressionist sensibilities.[6] Inseparable from the sea is the light that reflects off it, the light that makes it possible to see. Stout himself has said, "I think I have internalized Gulf Coast light."[7] The geography, light, and feel of the Gulf Coast not only formed Stout but became his lifelong aesthetic panacea.

The setting for so many of Stout's paintings and drawings is an unidentified water body or coastal scene. Since before he was born, his family has owned a fishing shack at Rollover Bay on Bolivar Peninsula— a slender spit of land on the Galveston Bay. His uncle had another place close by. The coast is an hour's drive from Houston. Stout returned to the bay area repeatedly over the years, during which time the literal fragility of the house on the aptly named Rollover Bay assured its destruction, twice: first by Hurricane Carla in 1961 and then Hurricane Ike in 2008. The tenuousness of human existence in Bolivar, always at the mercy of the vast and capricious ocean, resonated powerfully. Surrounded by water on three sides, his vulnerable coastal home would be transformed into a symbolic motif in Stout's paintings.

Beaumont

Stout's beginnings seem disarmingly inauspicious. Born in Beaumont in 1934, in the midst of the Depression, he was forced to repeat third grade because, he realized later, he was dyslexic.[8] Both his mother and father worked to help make ends meet; she continued to work after throat cancer claimed his father when Richard was fifteen. He recalls that it was clear, even before his father died, that he and his brother would have to "scramble to be good enough to get into school."[9]

Fortunately, Stout was skilled in art from an early age, and the Beaumont City School System (now Beaumont Independent School District) cultivated that artistic promise. Noted artist Lorene David (1897–1987) oversaw the arts programs within the district. Two instructors during these formative years were Mabel Best (1882–1947) in elementary school and Fanny Jones (1890–1977) in junior high school. At age twelve, Stout took drawing lessons from Robert Stapp (1873–1958) in Beaumont, learning how to render in charcoal accurately.[10] Artist Lillian Hayes (1920–1980) also took him under her wing. Soon Stout became, in his own words, "the darling" of the Beaumont Art League and Beaumont Art Museum, where a fourteen-year-old Stout befriended artists David (born 1929) and Patty Cargill (1929–2014).

Chicago

From that springboard he attended summers at the Art Academy of Cincinnati while still in high school (1952–1953), then received a four-year scholarship to the School of the Art Institute of Chicago (AIC) (1953–1957), where his teachers included Isobel Steel

MacKinnon (1896–1972), who studied in Munich with Hans Hoffmann (1880–1966); Laura van Pappelendam (1883–1974), and his artist–art history teacher, Kathleen Blackshear (1897–1988), who remained a friend her entire life. Stout's senior painting teacher, Paul Wieghardt (1897–1969), had studied at the Bauhaus. Equally influential on Stout, however, was the AIC collection itself, affording him his first glimpses of ancient through contemporary art, including work by Willem de Kooning (1904–1997), Arthur Dove (1880–1946), and Jackson Pollock (1912–1956).[11]

Many Central European instructors came to the AIC to teach before or after the war. Stout noticed an unofficial stylistic division at the AIC between the Eastern European (Hungarian, Russian, Latvian) and the Germanic teachers. The former group tended to pass on to their students a strong figurative and supernatural aspect of myth that permeated their class work. But Stout felt a kinship with the other camp, the Germanic point of view. He felt more in tune with Wieghardt's pedagogy, which veered somewhat away from strict Bauhaus structure toward an expressive figuration. Also in Chicago, Stout fell in love with another German product: Mies van der Rohe's (1886–1969) architecture, rising up all over the city before the young Texan's eyes.

Perhaps due in part to his disposition and part to early cultivation, Stout eagerly absorbed Chicago's culture. He shelved books at the Burnham and Ryerson libraries at the AIC; ushered for the Chicago Symphony; sold records at two bookstores; took academic courses at the University of Chicago so he could complement his AIC degree and studied the paintings in the AIC during his lunch breaks every day; exhibited in a two-man show with sculptor John Chamberlain (1927–2011); and participated in the Momentum exhi-

Bus Stop at Lincoln Park, 1953, oil on paper, 12 × 18 inches. Collection of Tom and Tam Kiehnhoff, Houston.

bitions (co-organized by Leon Golub [1922–2004] and others). Several significant paintings emerged from his Chicago days, including the whimsical *Red Bull* (1954), in which a smiling red creature with prominent linear ribs floats on an uninflected cream-colored field. *Yams and Yellow Onions* (1953) and *Bus Stop at Lincoln Park* (1953), begun in the same year, reveal Stout's discovery of Paul Cézanne (1839–1906). The former still life is built up through solid volumes heavy with brushstrokes; in the latter, rectilinear swaths of pale blues and greens create a landscape of trees. Cézanne's structural integrity appealed to him, as did the obdurate physicality of his brushstrokes. Classes at the AIC were intense. At the start of each week, for example, painting students would make an oil sketch on paper every thirty minutes for three hours, then use the remaining week to create the finished painting. Stout embraced that productive rigor, something that helped him maintain such a prodigious output to this day.

Houston

In 1957 and 1958 Stout traveled throughout the Northeast and East Coast, pausing to undertake a fellowship at Yale-Norfolk, the Yale School of Art program in Connecticut. It is noteworthy that Stout chose to settle in Houston near the Texas coast. In 1958 Stout became one of the one million new inhabitants who moved to Houston between 1940 and 1970. He settled on the "Magnolia City" after considering numerous other locations. He found himself lured by the artistic quality that already existed in Houston: Mies van der Rohe—with whose Chicago buildings Stout was well acquainted—was developing new wings for the Museum of Fine Arts, Houston; the Contemporary Arts Museum (founded in 1953) had recently shown the second US exhibition of Mark Rothko (1903–1970); as well as the presence of Dominique (1908–1997) and John (1904–1973) de Menil; Jim Love's (1927–2005) sets for Richard Strauss's (1854–1949) *Elektra* and *Salome* for the Houston Opera; Leopold Stokowski (1882–1977) as music director for the Houston Symphony Orchestra; and the Museum of Fine Arts, Houston program in the visual arts. The latter was run by Lowell Collins (1924–2003), who hired Stout in 1958. "People in Houston supported the arts because we didn't have Malibu," observes Stout. "We didn't have ski slopes. So we were stuck here reading, looking at art, and listening to music."[12]

It will come as no surprise to learn that Stout, a veritable scholar of an artist, is a knowledgeable historian of Houston and its art scene. His recall for detail is astounding. Stout was close with an assortment of artists, curators, directors, and historians, many of them now sadly gone. It is a testament to his independence and comfort with his own art making that he befriended such diverse and mercurial characters as Frank Dolejska (1921–1989), Jack Boynton, Dick Wray, and William Camfield (born 1925). He grew to know and admire all the artists, including Henri Gadbois (born 1930), Dorothy Hood, Ruth Laird (1921–2007), Paul Maxwell (1925–2015), Leila McConnell (born 1927), and Stella Sullivan (born 1924). Stout shared two studios with Boynton in the Houston Montrose area on Waugh Drive and later, Nance Street. As he did with Boynton, early on Stout became close, lifelong friends with Wray.

The late 1950s were critical aesthetic years for Stout. He positively exploded with expressionism in large-scale paintings like the 1956 series, *Seiche I, II,* and *III,* and the 1957 triptych of *Cave, Flowers,* and *Passion.*[13] The latter three were made in Chicago and exhibited at Wells Street Gallery, owned by Robert Natkin (1930–2010).[14] (Natkin, the Chicago-born

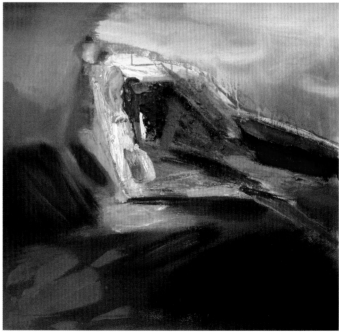

Blue Gibraltar, 1957, oil on canvas, 30 × 32 inches. Collection of Randy Tibbits and Rick Bebermeyer, Houston.

lyrical expressionist, painted a vibrant portrait of Stout seated in a chair with his hands crossed. As a nod to Natkin's influence, Stout painted *Untitled (red painting)* (1957) inspired by a red interior door that Natkin had painted at a Chicago apartment of a mutual friend. *Untitled (red painting)* was also exhibited at Natkin's Wells Street Gallery.) Another Stout painting, *Blue Gibraltar* (1957), features a square field with landscape characteristics: the lower region is deep blue and green, the upper half predominantly stormy-gray hued. The softly modulated background is interrupted by a thickly impastoed, fistlike shape of textured yellows, greens, magentas, and whites entering the canvas from the right. Despite its adamant nonobjectivity, *Blue Gibraltar* can be read as a metaphor for the artist's insertion of self into the landscape. That self is synecdochically represented by the form that echoes a wrist and fist, excitedly disrupting the placid surface. In titling his 1959 painting *I Went Down to the Sea*, Stout offers a rare direct indication of first-person presence. There is no need to search for the "I" in the picture; Stout is everywhere. His eye takes in the sea scene; his hand re-creates it through touch.

If this insertion of shape occurred in only a few of Stout's paintings, it might be dismissed. Yet Stout exuberantly inserts such motifs into landscapes throughout his career, developing it as a defining trope. Similar painted insertions appear in many late 1950s paintings and 1960s, including *Nest* (1958), *Tornado* (1957), *God (The West Wind)* (1957), *Love Nest* (1958), *Somewhere* (1958), an *Untitled* 1962 landscape (30 × 25 inches), and *Moonlight in Mexico* (1963). The enormous 1958 *Resurrection* (67 × 69 inches) evokes a seascape, with its horizon line and water, disrupted by a storm shape on the right half. Within the disturbance a funnel appears, which relates this painting to the

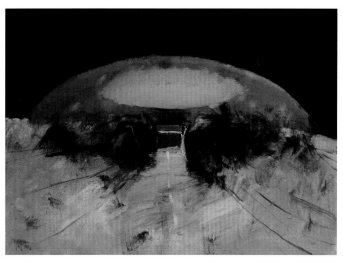

Dome, 1962, oil on canvas, 20 × 28 inches. Collection of Richard Stout, Houston.

Seiche series.[15] Stout has been fascinated by seiches, temporary oscillations in water bodies that are often caused by atmospheric pressure. They occur more frequently in water with narrow openings to a larger sea or gulf, like Galveston Bay. Although not included in the corpus of Stout's Seiche series, *The Black Wave* (1959) is a major work that alludes in title and image to an abnormal disturbance of the surface. It is easy to be pulled in to Stout's wide horizontal painting, to be absorbed in the elegant contrast of light surface and foamy black curves, without realizing the wave is heading in the viewer's direction.

Stout developed a further motif within his seascapes and landscapes: a prominent dome shape at the center of a horizon, generally centered within the canvas. The dome could be a sun or a moon rising or setting over the water. Many titles refer to a moon. Stout's longtime dealer Meredith Long, who ran the oldest art gallery in Houston, jokingly referred to them as the Astrodome paintings. Perhaps *Dome* (1962) instigated the nickname. A nightscape, *Dome* shows a central path leading toward an ominous

green-, gray-, and red-tinged hemisphere. Thin red orthogonal lines insistently draw the eye into the rectangular doorway of the dome. *Green Moonrise* (1963) is similar in structure, but with geometric blocks of pale color and a centralized expressionist area under the moon. Other significant works that vary the theme include *Blue Dome* (1964), *Untitled—R17* (1965), *Katy Prairie* (1965), *Gantries* (1965), *Small Exploding Sun* (1966), and *Geology Transformed* (1966). The dome could be read simply as the sun or a building, or it might be a representation of nature's inescapable presence, or even the self repeatedly confronting nature. It is worth recalling that Stout is, at heart, a Romantic in the vein of his idols Caspar David Friedrich (1774–1840) and the self-taught visionary Albert Pinkham Ryder (1847–1917).

Time after Time (1962) reinterprets the dome shape from above, but here as a radiating circle. The painting is compositionally unique in Stout's oeuvre. A tiny red and black vertical form (possibly human) is at the center of concentric circles, each depicted with a different value of light. It is as if we are looking through a blurry peephole or through a hyper-attuned eye. The repetition in the title, *Time after Time*, echoes the repeated forms. The title also has a dual resonance: time after time can mean "again and again," but it also could refer here to a time period that occurs after time itself has expired.

Early in his career Richard Stout began to incorporate architectural elements into his paintings and drawings. These forms appear in the 1961 *Remembrance* series, which includes *December*, *Remembrance*, and *Remember the Race*, among others. In these seascape paintings Stout inserts groups of rectangular planes (sometimes as sharply angled polygons), like a platoon marching toward the sea or fortifying the land. As in his paintings of dome structures that may be rising or falling, he plays on ambiguity. The presence of these incipient architectonic shapes is crucial, marking the first stirrings of Stout's long fascination with interiority and exteriority.

Another important painting from a different series, *SS Sweeney* (1968), shares these themes by combining the moon hemisphere with the rectilinear marching forms. The large painting also marks the confluence of Stout's artistic identity with his role as participant-observer in the city. *SS Sweeney* was named for James Johnson Sweeney, previously of

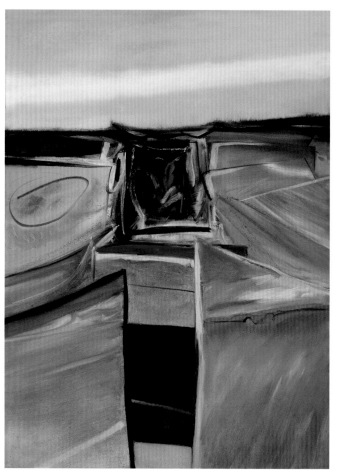

Remembrance, 1961, oil on canvas, 66 × 48 inches. Collection of Dianne Yeomans, Houston.

the Museum of Modern Art and the Guggenheim, who shook up the art scene in Houston when he became director of the Museum of Fine Arts, Houston (MFAH) in 1961. Striving to make the MFAH a world-class museum, Sweeney notoriously terminated the annual local exhibitions. He was moved by Stout's art, adding a 1961 painting to the MFAH collection. Stout's penchant for sea vocabulary is humorously employed here, evoking the concept of Sweeney as a sinking ship set against a pitch-black sky. He painted *SS Sweeney* the year Sweeney left Houston after clashing with the museum trustees. (Note the wispy white squiggle, like a lifebuoy on a thin skein of rope.)

In the 1966 *Home*, a crimson-red house sits precariously on the edge of a cliff against a bland cream-colored sky. The source material is of course his Bolivar home, which Stout has said was fifteen feet from the water on three sides. This house has been torn apart. Ocean-colored teal, deepest blue, and black mix with the red and pour out of the bifurcation. A potent symbol of devastation of all types, *Home* lets Stout equate expressionistic painterly gesture directly with intense emotional content. He followed this work with a companion piece entitled *Hamlet* (1966), delving further into this theme. Whether or not *Home* and its counterpart *Hamlet* had a cathartic effect on the artist, in his mature years, Stout would deeply explore the boundaries of building and sea, inside and outside.

In the 1970s Stout merged geometry with expressionism in a long series that sometimes would begin with an "X" diagonal that he then eradicated as exemplified by the painting titled *Houston* (1972). The 1970s paintings bear a strong kinship to Richard Diebenkorn's Ocean Park series, another great expressionistic artist whose architecturally inspired paintings merge subjectivity with objectivity, interior with exte-

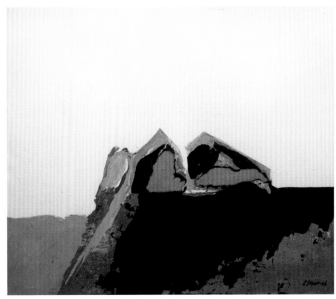

Home, 1966, oil on canvas, 34 × 40 inches. Collection of Richard Stout, Houston.

rior. Beginning in the 1980s, Stout's paintings often merged interior spaces, replete with architectural structures such as fenestrations or doorway, with the seascape.[16]

Given Stout's lifelong inextricable connection to the Texas coast, one expects him to include watery metaphors when discussing his work. Once when talking about the recurring imagery and themes in his art, he said, "So you swim through this sea of activity, which is all focused on working from the landscape, and it's delightful." In the same interview, Stout reflected that "over the long haul, certain things keep surfacing."[17] Just as "things" like houses, land, and even one's own bearings keep surfacing from the Gulf's maw.

Illustrations of the artwork discussed in this essay can be viewed in the gallery as images 1–25.

Notes

1. Richard Stout still works today from his home in the Montrose area in Houston.

2. Thomas McEvilley, *Richard Stout*: *Approaching the Limits of Space* (Houston: Richard Stout, publisher, 2004), 7 [exhibition catalogue].

3. Edmund P. Pillsbury, "Richard Stout: In Pursuit of the Sublime" (Dallas: Pillsbury Peters Fine Art, 2001), 2 [catalogue essay].

4. It could be argued that the work of another Beaumont native, John Alexander (born 1945), reveals a longtime affinity for and incorporation of Gulf elements. Yet Alexander's work is bound as much or more to the Southern landscape (and bayous) as it is to the coast.

5. Edmund P. Pillsbury recalled Konrad Oberhuber's observation at a conference of the Center for the Advancement and Study of Early Texas Art, AT&T Executive Education and Conference Center, May 1, 2007, Austin, Texas. Pillsbury, once a student of and later collaborator with Oberhuber, has written on Stout's work.

6. William Reaves, e-mail correspondence to the author, 2016.

7. Interview with the author, Houston, Texas, August 6, 2007, courtesy of Baylor Institute for Oral History, © Baylor University, 32.

8. Stout's dyslexia made it difficult for him to write; the artist has always been an avid and voracious reader.

9. Interview with the author, Houston, Texas, August 6, 2007, courtesy of Baylor Institute for Oral History, © Baylor University, 2.

10. The Beaumont Art League was founded in 1943 by artists who met regularly at Robert Stapp's studio. Among others, Tom Tierney (1928–2014) and Will-Amelia Sterns Price (1907–1995) were two important founding members.

11. Stout's favorite Jackson Pollock painting is unusual for Pollock but apt for Stout: *The Deep* (1953, oil and enamel on canvas, Centre Georges Pompidou, Paris).

12. Pete Gershon, "Panel Discussion of Pow Wow: Contemporary Artists Working in Houston, 1972–1985," uploaded May 31, 2015, https://www.youtube.com/watch?v=pXSmYYIhAXk.

13. See the references to *Seiche I*, *Passion*, *Cave*, and *Flowers* in my *Midcentury Modern Art in Texas* (Austin: University of Texas Press, 2014), 198. Additionally, an important oil field canvas Stout painted at sixteen, *Twin Derricks*, is reproduced in the introductory chapter (4).

14. These paintings were featured in a joint exhibition with John Chamberlain. Some of Stout's later sculptures bear a resemblance to the works Chamberlain exhibited with Stout in 1957. See the article on Natkins's gallery: Jason Andrews, "The Wells Street Gallery," *Brooklyn Rail*, March 4, 2010, http://www.brooklynrail.org/2010/03/art/the-wells-street-gallery.

15. A major earthquake in Alaska in 1964 caused seiches up to six feet high in the Gulf of Mexico. See Bethany D. Rinard Hinga, *Ring of Fire*: *An Encyclopedia of the Pacific Rim's Earthquakes, Tsunamis, and Volcanoes* (Santa Barbara, CA: ABC-CLIO, 2015), 75. One wonders if Stout had earlier seen unrecorded seiches in the Gulf.

16. Stout's interiors are beyond the scope of the current essay but have been written about, for example, by Steven Mansbach, *Richard Stout*: *Structures of Intimacy* (Houston: Richard Stout, publisher, 1997) [exhibition catalogue]; Ileana Marcoulesco, *Richard Stout*: *The Arc of Perception* (Houston: Richard Stout, publisher, 2006) [exhibition catalogue]; David Brauer, *Richard Stout*: *Alternate Realities* (Beeville Art Museum, January 16–April 22, 2010) [exhibition catalogue].

17. Interview with the author, Houston, Texas, August 6, 2007, courtesy of Baylor Institute for Oral History, © Baylor University, 15.

THE SILENCE THAT LIVES IN HOUSES (AFTER HENRI MATISSE)

David E. Brauer

In God, the entire life of a person stands eternally in juxtaposition like a painting, in which light and shadow intermingle beautifully, whereas the human being must live through it to comprehend it.
—KARL PHILIPP MORITZ, 1787

Richard Stout's life and works have been the subject of several essays by a series of distinguished writers: for example, Susie Kalil, Elizabeth McBride, Tom McEvilley, Michael Tracy, Ted Pillsbury, and Ileana Marcoulesco. All have contributed insightful, trenchant commentaries regarding Stout's long career as an artist and teacher. What more might be said? A rhetorical question, of course. The sheer volume of writing about art and artists shows that there is always more to be said, but only of very good work. History teaches us that mere facts do not constitute truth, a variable from generation to generation, hence the need for constant exegesis.

We have all forgot more than we remember.
—THOMAS FULLER, 1732

Stout has been, and remains, primarily a painter, also a printmaker, and in recent years sculpture has become a significant presence in his work. Stout is one of the few artists who can give acrylic the depth of oils. This current overview shows clearly the changes that emerged in Stout's painting from circa 1985, an expressive deepening probably brought about, as McEvilley notes in *Richard Stout: Approaching the Limits of Space* (2004),[1] by personal tragedy in the artist's life. What resulted was new emphasis on how interiors and exteriors compenetrate as they evolve from views to states of mind.

It is somewhat inescapable that in writing about an artist, comparisons can be drawn that place the works in some hopefully illuminating context. All images have their genealogy and archaeology. All artists know other art and usually find their own tribe. Because of Stout's preoccupation with interior/exterior relationships, an obvious point of departure might be the Dutch interiors of the seventeenth century, not merely because they are interiors but because, in that new Protestant republic, most seemingly secular subjects in Dutch paintings—landscapes, still lifes, flower paintings, and interiors—also could possess a covert symbolism, often of a religious nature.

By the late seventeenth century, the interior genre had become one of the great achievements of Dutch art, seen most clearly in the paintings by Pieter de Hooch (1629–1684), Johannes Vermeer (1632–1675),

and Pieter Janssens Elinga (1623–1682). While most of the paintings by de Hooch show a relationship outside to inside, through open doors and windows, in Vermeer the interiors are self-contained, the windows rarely offering a view of the outside world, although two of his greatest works, *The Little Street* and *View of Delft*, show only the outside. It is, however, in the fewer and lesser-known works of Janssens Elinga that inner and outer worlds become one, views of sky and trees seen through high windows, angles of light streaming inward, evoking a stillness and silence rivaling that of Vermeer.

A later line of interiors might be traced to a few works by Edgar Degas (1834–1917) and John Singer Sargent (1856–1925), even Giorgio Morandi (1890–1964), these works permeated not so much by loneliness as aloneness, separateness. No hint here of Nabi-style domesticity, reading by lamplight, rich patterns, or company but another tone that connects Stout to something specifically American, not so much of imagery but of feeling: Albert Pinkham Ryder (1847–1917), Winslow Homer (1836–1910), Thomas Eakins (1844–1916), Edward Hopper (1882–1967), and Andrew Wyeth (1917–2009).

The most obvious difference between the interiors of Richard Stout and those of the Dutch lies in the virtual absence of human figures. Imagine Stout's interiors populated by figures or, conversely, those of the Dutch depopulated. There is a way in which we can contemplate the latter. The distinguished painter Sophie Matisse (born 1965), great-granddaughter of Henri Matisse (1869–1954) and stepdaughter of Marcel Duchamp (1887–1968), has produced a fascinating body of work in which she has meticulously painted copies of Dutch old masters, most notably *The Art of Painting*, the great work by Vermeer, in which she has omitted the figures of the artist and the model, as though we have just entered an empty studio. Yet the room is, through memory, permeated with the presence of the two figures.

Memory and Mortality

Our memories are independent of our wills. It is not easy to forget.
—RICHARD SHERIDAN, *THE RIVALS*, 1775

Within the parameters of Stout's expressive concerns there exists a wide variety of subject matter. Some works appear to be quite literal, more often allusive, at times closer in spirit to aspects of surrealism, a movement much concerned with the interior world but given external forms. Is it a complete coincidence that a deep change in the artist's personal life was almost confluent with the opening of the Menil Collection in 1987, with its great holdings of surrealist works, many of which had previously been exhibited at the Rice Media Center? Stout is well traveled, and it might be tempting to suggest the artist's awareness of lesser-known surrealists such as the British artists Paul Nash (1889–1946) and John Tunnard (1900–1971); and German artists Karl Hubbuch (1891–1979), Rudolf Schlichter (1890–1955), and Franz Radziwill (1895–1983). Again, this is not a superficial stylistic affinity but an expressive tone, a timbre in certain works—*The East Wall*, *The Citadel*, *Damascus Gate*, and *Night Sailing*, all from 1997; *Winter Light*, 1998; *Sound*, 1999; *Solstice* and *Lago*, both from 2005.

The effulgent quality of Stout's color reveals time and memory rather than matter, what we move through to attain what the German painter Max Beckmann (1884–1950) characterized thus, "If you

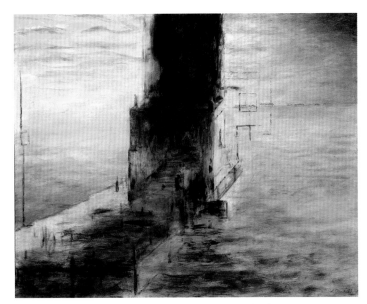

The Citadel, 1997, acrylic on canvas, 50 × 62 inches. Collection of Tara Lewis and John Swords, Dallas.

wish to get hold of the invisible, you must penetrate as deeply as possible into the visible."[2] Stout is not a painter of the people inasmuch as the specific human presence is never literal, especially after 1985, and not that much before. However, absence resonates between moment and memory as conveyed in Stout interiors such as *The Sweetest Room in the House* (1991) and *Ron* (1992).

We do not remember days, we remember moments.
—CESARE PAVESE, 1961

The interiors are still there, even if we are absent. Everyone has had the experience of entering a room in which there is a palpable sense of previous presence, of invading the privacy of the room, of having broken a silence. Among his last paintings, most of which were interiors, Henri Matisse gave the title *The Silence That Lives in Houses*.

Stillness and Silence

Paintings are permeated by both of these qualities, which are becoming increasingly rare in the world. Stillness and silence, space, time and memory are the essential ingredients of Stout's recent works. The cumulative power of these works moves us beyond aesthetics to philosophy; these are refractive meditations on the nature of existence itself, that perpetually changing condition of the now. Rudolph Arnheim, in his essay *Space as an Image of Time*, notes that "space and time behave differently depending upon whether we are concerned with the existence of things in the physical world or in consciousness. I cannot be aware of the physical presence of an object unless its lifeline runs parallel to mine for a period of time."[3]

Stout's Tropes

As occurs for any accomplished painter working over a sustained period of time, certain tropes find their way into the artist's compositions and become signature constructs that amplify expression and style unique to that artist. In Stout's later paintings, corridors and especially corridors distinguished by personal items or remembrances, seem to have become the central trope for his deft compositions.

To Thebes, 1995, shows an open vitrine on the left, the bright light that illuminates the center, Stout's father's chair, a red lampstand; then, farther on, a chest of drawers seen in a darker room, while to the right another chest, a chair, and a hint of a woman's dressing table.

One is rather reluctant to interpret or overinterpret works by any artist, even when they are willing to divulge such information. The painting must ultimately stand on its own.

Winter Light, 1998, offers a more ambiguous image, not only the large red armoire but the absence of a wall on the right-hand side of the painting, looking out to an ocean vista, an image tending more to the surreal.

On Course, 2015, has the corridor image refracting into an even more ambiguous space, as is the case with *Echo*, 2015; spaces that become prismatic, specific items, chairs, and so on, as seen in *Winter Light* and *To Thebes*.

The Night Light, 2015, juxtaposes several dimensions of layered spaces. Working from the lower horizon, which might be read as a jetty, takes the eye from

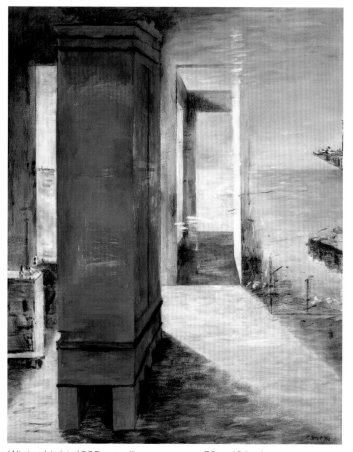

Winter Light, 1998, acrylic on canvas, 50 × 40 inches. Courtesy of the artist.

the bottom of the painting seen through a red lattice from which other perspectival shapes emerge. The upper left introduces a pyramid form that seemingly emerges from its own horizon. The lower and upper levels are connected by a light orange vertical line. One of the most complex of Stout's recent works while remaining resistant to interpretation, to all intents and purposes for the viewer the painting is the content.

Damascus Gate, 1997, shows a window, which runs from floor to ceiling, angling to the left of the painting. The view is an expansive vista of water, presumably the Gulf of Mexico, reminding the viewer that Stout was born on the Gulf in his native Beaumont. In the lower right of the painting there appears part of a platform extending into the water. A late afternoon light gives a feeling of expansive clam.

From a High Place, 1998, shows a darker mood. A black, starless night sky, which nonetheless suggests a full moon illuminating silvery, shiny, level water. In the foreground there is the suggestion of a veranda, an angled awning at the top, a diagonal wall at the bottom, the painting dissected by two red verticals, the left being thicker with a shadow edge; the other, a thinner line. The whole has an irresistible sense of a Barnett Newman (1905–1970) painting, whose work is well represented in the Menil Collection.

Hidden Voyage, 2000, introduces an even darker mood. Again, a basic window format is used, but less literal: An interior on whose floor lies a slab of bright light, also illuminating two thin columns from the light of an open door. Outside, darkness. A row of trees on a seemingly snowy ground, the trees silhouetted against a cold Prussian-blue sky.

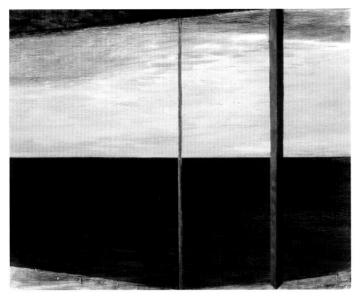

From a High Place, 1998, acrylic on canvas, 40 × 50 inches. Collection of Nancy Manderson, Houston.

A man's real possession is his memory. In nothing else is he rich, in nothing else is he poor.
—ALEXANDER SMITH, *DEATH AND THE FEAR OF DYING*, 1863

So it ends as it begins: the artist alone in the studio, one of the last sanctuaries of solitary meditation in a world smothering in fugitive nonimages, turning, as the critic John Berger notes, "appearance into refractions, like mirages; refractions not of light but of appetite, the appetite for more."[4] Or, as Samuel Johnson observed, "The measure of time may be varied so as very strongly to represent, not only modes of external motion, but the quick or slow succession of ideas and consequently the passions of the mind."[5] In the fluxity of the present techno-haze, the singularity, stillness, and silence of Richard Stout's work offer an oasis of fixity.

Life is all memory, except for the one present moment that goes by you so quickly you hardly catch it going.
—TENNESSEE WILLIAMS, *THE MILK TRAIN DOESN'T STOP HERE ANYMORE*, 1963

The Traveller Has Regrets

The traveller has regrets
For the receding shore
That with its many nets
Has caught, not to restore,
The white lights in the bay,
The blue lights on the hill,
Though night with many start
May travel with him still
But night has nought to say,
Only a colour and shape
Changing like cloth shaking,
A dancer in a cape
Whose dance is heart–breaking,
Night with its many stars
Can warn travelers
There's only time to kill
And nothing much to say:
But the blue light on the hill,
The white lights in the bay
Told us the meal was laid
And that the bed was made
And that we could not stay.[6]

Illustrations of the artwork discussed in this essay can be viewed in the gallery as images 26–39.

Notes

This essay is adapted with permission from the author's literary composition published in the catalogue accompanying Stout's 2010 exhibition at the Beeville Art Museum titled *Richard Stout: Alternative Realities*.

1. Thomas McEvilley, *Richard Stout: Approaching the Limits of Space* (Houston: Richard Stout, publisher, 2004), 10 [exhibition catalogue].

2. Max Beckmann, "On My Painting," in *Ten Unabridged Essays*, edited by Robert L. Herbert (New York: Prentice-Hall, 1964).

3. Rudolph Arnheim, "Space as an Image of Time," in *The Split and the Structure: Twenty-Eight Essays* (Berkeley: University of California Press, 1996).

4. John Berger quote from class lectures given by author at the University of Houston and the Museum of Fine Arts, Houston between 2003 and 2010.

5. Samuel Johnson quote from class lectures given by author at the University of Houston and the Museum of Fine Arts, Houston between 2003 and 2010.

6. G. S. Fraser, *The Traveller Has Regrets and Other Poems* (London: Harvill Press & Editions Poetry, 1948).

SCULPTURE

Jim Edwards

In the March 2004 catalogue *Richard Stout: Approaching the Limits of Space*, the late esteemed writer Thomas McEvilley made a case that Stout's tabletop sculptures are more nearly postmodern than his better-known paintings, "if only because of the use, in many of them, of found crumpled cardboard scraps as their beginnings—somewhat as Robert Rauschenberg (1925–2008) did in the 1960s."[1] McEvilley is being sensitive to the inherent physical properties of Stout's newly found material and the possibilities for these scraps being made anew as sculptural supports. There are in fact big differences between Rauschenberg's large-scale, mostly flat-to-the-wall, cardboard works—especially from his Card Birds series—and Stout's more diminutive sculptures that have their beginnings as folded cardboard transformed into a lost-wax, cast-bronze finish. In Rauschenberg's use of cardboard, one is always aware that it is an altered box, whereas Stout's use relies on the more abstract cut or crumpled fragments. Cardboard is the most common of materials to be found on the street, an abandoned packing material for all kinds of objects. As a paper product it is sturdy, and its thick outer papers encase a corrugated center, making it an ideal material for the construction of sculptural projects. The ability to crease, cut, fold, and tear cardboard and heavy paper and add other materials such as string and twigs allows Stout to work quickly, as well as to make numerous changes in the process of constructing sculptural forms that will later be waxed and bronzed. Stout has further demonstrated this facility in recent sculpted cardboard creations, including *Hunter* (2014), *Lift Off* (2014), *Answer Me* (2015), and *To Fly* (2015), where, in lieu of wax and bronze, the artist has applied luxurious painted surfaces directly to the cardboard.

As a sculptor, Stout got a relatively late start. It was in 1999, at the encouragement of his friend artist Michael Tracy (born 1943), who was then living near Guanajuato, Mexico, that Stout started to seriously explore his newly found interest in sculpture. In an e-mail to me, Stout wrote about his working conditions in Mexico: "Michael Tracy by that time was working in a small complex of buildings in the village of Valenciana. It is one of the mining towns about a half-mile above Guanajuato and is the site of the Basilica of St. Cayetano, one of the Baroque treasures of Mexico. The church was two blocks from where I lived. I worked at this site from January 1999 until 2002."[2] From 2002 to 2004 Stout rented a house that was once an eighteenth-century assay office for a nearby mine.

It is pure speculation on my part to think that

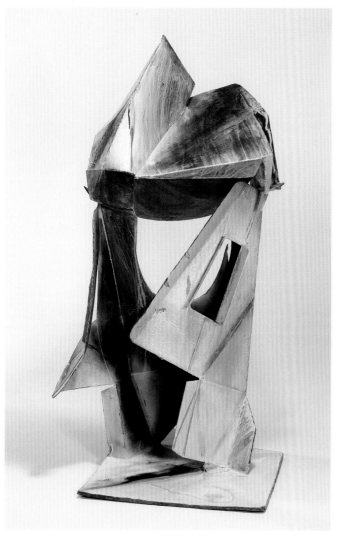

Answer Me, 2015, mixed media assemblage, 25 × 16 × 16 inches. Collection of Richard Stout, Houston.

of central Mexico afforded a break from his Houston studio while offering an opportunity to explore new ideas in a new medium. Mexico has played an important part in the development of modernism. During the Second World War, the American painter Robert Motherwell (1915–1991) joined the surrealists Roberto Matta (1911–2002) and Wolfgang Paalen (1905–1959) in Mexico, war and death being very much on their minds. Motherwell was also moved by the indigenous sense of death inherent in the Mexican culture. He wrote, "The presence everywhere of death iconography: coffins, black glass enclosed horse drawn hearses, sigoa skulls, figures of death, corpses of priests in glass cases … women in black, cypress trees in their cemeteries, burning candles, black edged death notices and death announcements … all this contrasted with bright sunlight … everything you associate with life— all seized my imagination."[3] By 2004, Tracy and Stout had abandoned Mexico because the drug wars in that country, and the distrust of foreigners in central Mexico, made it unsafe to remain there.

In the catalogue *Richard Stout: The Arc of Perception*, essayist Ileana Marcoulesco suggests, "Stout was working on the perspectival approach in sculpture, an innovation so radical as to make one wonder how much of it was intended, preconceived maybe, and how much was the result of fortunate encounters."[4] My thinking is that his working method was intended and fortunate. The opportunity to leave the familiar setting of his studio in Houston and temporarily relocate opened up his senses. There, in La Valenciana, he could explore a new creative freedom, and his daily walks led to and included collecting street trash that became the beginnings of his sculptural projects. Away from the paintings and stretched canvases that were stacked up in his studio in Texas, Stout allowed

his part-time residence in Mexico provided Stout an opportunity for renewal by engaging in an art form that he had not practiced since his student days at the Art Institute of Chicago. This new passion for sculpture followed a highly personal and successful forty-year career as a painter based in Houston and on Bolivar Island on the Gulf of Mexico. The relocation from a humid coastal zone in South Texas to the mountains

himself to begin a process of assemblage, arranging his found materials three-dimensionally rather than pictorially. He was also free from the restrictions of the rectangular shape of his canvases.

As Stout embarked on a sculptural journey, the freedom that he experienced with the construction of his modest scaled sculptures was pivotal. Modernism is abundant with artists who discovered techniques at an important junction in their careers that proved to enhance their work in other mediums. There is the example of Georges Braque's (1882–1963) discovery of collage and Max Ernst's (1891–1976) frottage method of rubbings that he began on the floorboards of a hotel in France while he was on vacation. One is also reminded of Motherwell's statement in 1946 about the tactile sensation when creating a collage: "The sensation of physically operating on the world is very strong in the medium of papier colle or collage, in which various kinds of paper are pasted to canvas. One cuts and chooses and shifts and pastes, and sometimes tears off and begins again. In any case, shaping and arranging such a relational structure obliterates the need, and often the awareness of representation. Without references to likenesses, it possesses feeling because all the decisions in regard to it are ultimately made on the grounds of feelings."[5]

Some of Stout's earliest sculptures made use of a platform or base. *Hellespont* and *To Cythera*, both from 1999, support forms that rise upward from flat bases that are parallel to the tables on which they rest. Like his paintings of the late 1990s, Stout's initial venture into sculpture makes reference to architectural forms. *The Library at Alexandria* (1999) has the appearance of an architectural fragment, and *Knossos* (1999), a multilevel form (like an abandoned oil platform), makes reference to the ancient city in Crete, Europe's oldest

city and an important center during the Bronze Age. Other early works, like *Voyage* and *Homecoming*, two unique bronze sculptures from 2002, are decidedly linear in their compositions. Like twigs or thin leafless branches they reach up, balanced on the tabletop at stunted points.

As a very young artist, in the early 1950s, Stout came across a book on Alberto Giacometti (1901–1966), the great Swiss artist, whose wiry, cage-like, surrealist sculptures have been something of an influence. In Stout's later sculptures produced in Mexico, Giacometti's impact, and also that of Isamu Noguchi (1904–1988), whose public installations and gardens have had some effect on Stout's sense of placement and scale, is perceived in the authoritative presence of the Texas-based artist's own sculptures. During a late August 2015 visit I made to his Houston studio, Stout mentioned that he has always been an "arranger." This is evident even in the arrangement of his studio and the shelves on which his small-scale sculptures sit. They are arranged in long rows, each with an identification tag, a practical storage solution but also exhibit worthy as an installation just as they are arranged on the shelves.

The modeling wax that Stout used in Mexico was very soft and required armature for support. Much care was needed in transporting his wax forms from his studio to a foundry in Mexico City. During hot summer months, while he drove his work to Mexico City, the wax could start to melt before reaching the foundry. Prior to casting, his found materials, including cardboard, smashed plastic bottles, twigs, and string, were bound together into assemblage-like unique forms. Michael Tracy's friend, the producer Vicente Cellis, would transfer Stout's works to Mexico City, and once they were cast, he would drive them to

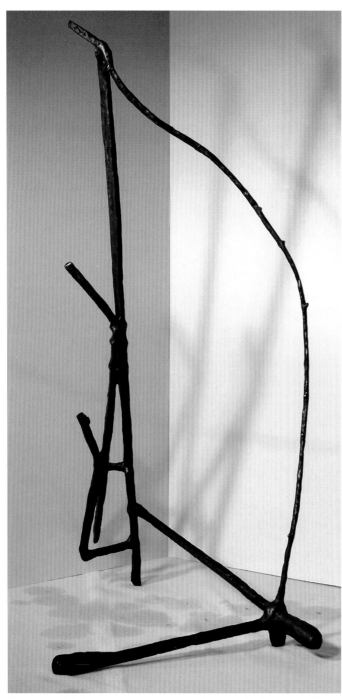

Voyage, 2002, bronze, 32.5 × 23 × 15 inches. Collection of Glenn Thomas Turner, Houston.

Tracy's home on the border of the Rio Grande in San Ygnacio, Texas, where Stout would pick them up and bring them back to Houston. Stout completed eighty-nine sculptures during his time in Mexico. Once Stout stopped casting his bronzes in Mexico, he worked with two foundries in Houston: first with Tim Hates at United Metalsmiths and then with Scott Yoast at Texas Fine Art Foundry. Since 2004, Stout has cast forty bronzes in these two Texas foundries.

In February 2016, I visited the Peggy Guggenheim Collection in Venice, Italy, and in a side gallery featuring a selection from the Hannelore B. and Rudolph B. Schulhof Collection there was a case featuring several small-scale sculptures, including the American sculptor John Chamberlain's (1927–2011) painted and chrome-plated steel sculpture *Tiny Piece #1* (1961). Chamberlain's diminutive sculpture, no bigger than the size of a small sardine tin, immediately caught my attention: first because of its miniature size by a sculptor who is best known for his large-scale assemblages of crushed automobile bodies, and second because *Tiny Piece #1* also immediately brought to mind the sculptures by Richard Stout. There are clear differences between the sculptures of these two artists. Chamberlain constructs his assemblages from automobile parts and various metals, while Stout casts his ephemeral found materials in bronze, but it struck me that both artists possess an innate ability to arrange various shapes in structural compositions that simultaneously compress and expand space. It seems that in either case if the scale of their art is correct, then the size of their sculptures does not matter as much. I am of the opinion that a Stout sculpture, for instance, the 2005 bronze *Hero* that measures only 19 × 24 × 15 inches, would work just as well if its dimensions were in feet rather than inches.

Stout is recognized primarily as a painter, although

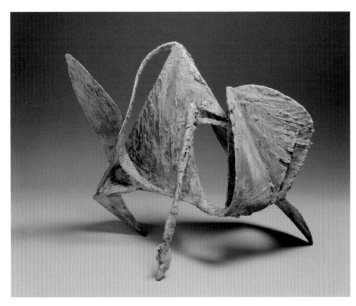

Hero, 2005, bronze, 19 × 24 × 15 inches. Collection of Kathleen and George DeMartino, Dallas.

he has continuously exhibited his sculptures along with his paintings since the late 1990s. The pictorial demands of painting present obvious differences with those inherent qualities particular to sculpture. Stout's colorful paintings, whether figurative or abstract, render the illusion of light and space as transitory. In his abstract bronze sculptures, time is seemingly arrested; a sense of permanence has been given to the organic forms. There also exists in some of the sculptures an homage to an ancient time. Two sculptures from 2004, *Atlas* and *Galatea*, make reference to a Greek god and goddess. In comparing Stout's paintings with his sculptures, it is clear that they are separate initiatives that share compositional qualities. References to linear architectural forms will occur, and the cast triangles of shadows that appear in the paintings will occasionally appear in the folded forms of the bronzes. The formal comparisons between the paintings and the sculptures were perhaps most closely aligned in his exhibition

Richard Stout: The Arc of Perception, which was held at his residence in March 2006. The real and implied horizon that occurs in even the most abstract of these paintings does not exist in the sculptures; instead, straight and curvilinear lines define the illusionistic space of the paintings as well as the concrete forms of the sculptures. Different impulses seem to govern Stout's work in painting and sculpture. The small-scale bronzes possess a tactile immediacy, heightened by the limited range of the colors of their patinas: green-grays and dusky graphite-silvers.

Memory, as well as a sense of time, is implied in Stout's bronzes. Personal memory resulted in his creation of *Opus 1* (1999), a re-creation from a sculpture that he originally made for Kathleen Blackshear's (1897–1988) composition class as a young student at the Art Institute of Chicago. The 129 bronze sculptures that Stout has created during the course of the last sixteen years are a testimony to a uniquely original and human expression. Contained in these sculptures is their own history. Stout turned scraps and street debris into an homage to the transformations of nature, memory, and time through the tactile abstract beauty of the small-scale sculptures that he has created.

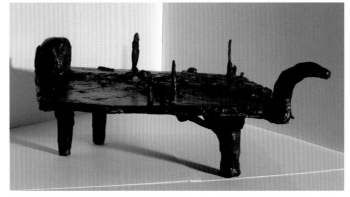

Opus I, 1999, bronze, 7.5 × 15 × 16 inches. Collection of Rick and Nancy Rome, Dallas.

Illustrations of the artwork discussed in this essay can be viewed in the gallery as images 40–53.

Notes

1. Thomas McEvilley, *Richard Stout: Approaching the Limits of Space* (Houston: Richard Stout, publisher, 2004), 17 [exhibition catalogue].

2. Richard Stout, e-mail message to author, November 11, 2015.

3. Robert S. Mattison, *Robert Motherwell: Early Collages*, College Arts Association Review, July 17, 2014, http://www.caareviews.org/reviews/2184#.WIJqD32XmNM.

4. Ileana Marcoulesco, "The Leap of Invention," in *Richard Stout: The Arc of Perception* (Houston: Richard Stout, publisher, 2006), 13 [exhibition catalogue].

5. Stephanie Terenzio, ed., "The Collected Writings of Robert Motherwell," in *Documents of Twentieth Century Art* (London: Oxford University Press, 1992), 37.

A VISION OF HOME

Sarah Beth Wilson

Anyone who has met Richard Stout knows that he embodies a certain presence. Specific words come to mind when I think of how best to describe him—intelligent, elegant, sophisticated, witty, original. Although a simple word, this last characteristic is a distinguishing feature; many artists strive for originality—a fresh and raw vision—but few truly embody the essence of the word. Richard is a highly original artist with an uncompromising vision for his past and present artwork. This constant vision is the foundation that binds the bravura of his early paintings with the brilliant sophistication, both visually and thematically, of his current body of work—exploring new and invigorating horizons in both two and three dimensions. Richard ventures into these open waters with seamless ease, effortlessly transitioning between media and scale as if he is in a familiar place among old friends. This synergy between place and home is the driving force to Richard's originality, which not only resonates in his oeuvre but also describes his lifestyle.

I first met Richard in the fall of 2009. I was fresh out of graduate school and working for Houston artist Jack Boynton (1928–2010), creating an inventory of his art. Although my studies certainly prepared me to enter the art world, it was through working with Jack, in particular, that I was able to experience art and understand what it "feels" like to live among and work with your passion. While working with Jack, I enjoyed listening to his stories about the old art world in Houston that once was but is no longer here. I heard quite a few names of local artists who at the time meant nothing to me but are now considered dear friends. One of those names was Richard Stout. Although I had yet to meet Richard, I could tell through Jack's words that he was an influential and significant person and, according to Jack, an artist I ought to know. During this time, Jack also introduced me to William Reaves, owner of William Reaves Fine Art in Houston (now William Reaves | Sarah Foltz Fine Art), where I accepted a position first as gallery intern and then as gallery assistant. Although I did not know it at the time, a world of Texas art history was now at the tips of my fingers and literally about to walk through the door.

Almost every Friday, like clockwork, Richard Stout visited the gallery. He would spend time with the fresh art hanging on the gallery walls, examining every stroke, stepping close and then moving away, and absorbing the atmosphere of the space. Many times we would all take a break from work and stop to speak with Richard, often taking a seat in the lounge area at the center of the room. As I reminisce

on these moments, I recall watching Richard as he moved throughout the space, and I intently listened to the stories he told—he does not waste words. There is a sense of experience and intention behind every look and story, enthralling listeners, allowing them to feel as if they are part of Richard's thoughts and have been granted permission to enter his sense of place. This is where I received the most complete and detailed account of Houston's art historical genesis, its climax, and Stout's critique of the current art world. I quickly assessed that Richard was both an artist and revered historian and is to this day a vital person to consult on midcentury Houston (and Texas for that matter) art museum, gallery, and artist history. Anyone who has heard Richard recount this history can sense a definite ownership of the stories and knowledge that comes only from someone who has truly lived and thrived in the surroundings that he calls home. A native Texan born and raised in Beaumont and a longtime resident of Houston, Richard has lived in the midst of the formative art historical years of our state, and during this time he has devoted his life to creating a body of work that is original in vision and sense of place.

During my tenure at William Reaves Fine Art, I became familiar with both Richard's older and more recent works. I will never forget the first time I encountered the beauty of *Passion* (1957) as it hung on the gallery walls. I remember being entranced by the spontaneous, vivid centrifugal combustion of color and form as it dynamically propelled into space, rife with energy and expression. I knew then that such virtuoso and mastery of space comes only from a mind that understands where it is, where it is going, and where it hopes to be. This is a highly original vision and one that resonates throughout Richard's art.

What I find fascinating—as I have grown to know

Richard, visited with him in his home, viewed more of his art, and experienced his philosophy—is his sophisticated transposition of this concept from his earlier works to the present day. In paintings, such as *Morning* (2005) and *Headlands* (2012), there is a similar attention to spatial surroundings and purposeful injections of color that draw attention to place and the movement of planes within the composition. Stout's dissection of the picture plane into multiple horizon lines, as seen in *Morning*, *Headlands*, and, in particular, *Patagonia* (2010), visually brings to mind the magnificent, seemingly omnipotent clouds with fiery slivers of emblazoned sun emerging from the mist that so often characterizes his native Gulf Coast skyline. Anyone familiar with this view knows that the sky can go from a dusky, smoke-gray to a rainbow of color in a matter of minutes, and often the most stunning, jewel skies of azure and cobalt blue and crimson and violet bursts of sun emerge after the most destructive storms, giving a sense of renewed life in this place we inhabit. Stout's *Night Fishing* (2004) is a visual treatise that praises the violent surrealism and serene beauty of coastal skies.

Patagonia, 2010, acrylic on canvas, 50 × 70 inches. Collection of Richard Stout, Houston.

His paintings from this period, in particular, show strong visual kinship to works of the late 1950s in their masterful and commanding development of color—expertly pushed in and out of the composition and maximizing expressionist potential.

I am, like Stout, a native of Southeast Texas, and I have lived in the region most of my life. Shortly following my tenure at William Reaves Fine Art, I accepted my current position as curator at the Art Museum of Southeast Texas in Beaumont. I continue to live in Houston and drive to Beaumont—some would say committing to this sort of commute is most certainly senseless. While there are times I might agree, I will counter that many days this drive is one of my most mentally productive and cathartic moments. The time gives me a moment to pause, regain a sense of composure after a hectic day, and feel at peace where I am. My parents also live in Southeast Texas, so between work, living in Houston, and holidays with family, I find myself fully immersed in the region. When I was a child, my family often vacationed in Galveston, and I continue to frequent this coast as an adult. I have experienced torrential deluges, the brightest rays of sun, and the most horrid whipping winds living in Southeast Texas, and many times I find myself staring off into the distant horizon and thinking of Richard's art, especially when I watch the storm clouds roll over and clear Interstate 10 during my commute, making their passage from the coast. Stout's recent paintings, *A Day at Rollover Bay* (2015) and *The Way* (2016), attest to his devotion to his coastal home, in both a visual and philosophical manner, and the continuation of his original vision into his most recent body of work.

During my first week at the art museum, I picked up my mail and was stunned to see a hand-

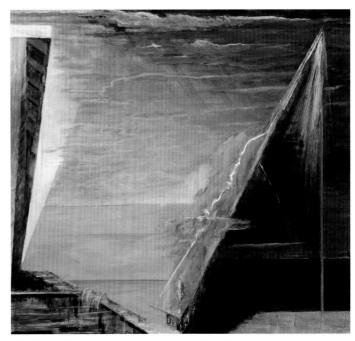

The Light, 2014, acrylic on canvas, 60 × 70 inches. Collection of Richard Stout, Houston.

written envelope addressed to me. I opened the letter and pulled out a notecard revealing Stout's *The Light* (2014), and I immediately felt as if I were at home—in the right place at the right time. Richard wrote to congratulate me in my new role and express his excitement at my new venture, and at the end of the note he penned, "I know you are happy to be near family and the museum is a great institution." I remember being shocked that Richard recalled I was from Southeast Texas and that taking the position at the museum literally moved me back to the place I call home. Now, as I look at Richard's body of work over the years and am presented with the opportunity to curate an exhibition of his artwork from the 1950s through the present at our museum, I realize that Richard's sense of home and place is a resounding element, integral to his very being and spirit. You do not forget where you come from, and for Richard, this concept resounds as a core

and philosophical truth, intrinsic to his being, creative forte and artistic vision.

The significance of Stout's expansive career, oeuvre, and art historical prominence is examined at great length in this book and accompanying exhibition. In the current art world where questions and critiques of "what is art?" and "what does it mean to be an artist?" are in constant flux and debate, Stout's longevity and success in this realm necessitate examination and due diligence. To create art and truly live and work full-time as an artist seems an impossible dream to many, but Stout has, in a sense, curated his life around this passion and done so with laudable success (the artist, however, speaks of these achievements with great humility). He has avoided the arguable trajectory of many artists who have an early or midcareer peak with somewhat less success to follow. While Stout undoubtedly garnered success in his early years, he continues to paint, exhibit, and build on his pictorial vocabulary, thus boasting an impressive résumé with numerous exhibitions, publications, and accolades through the present day.[1] He has waded through the muddy trenches, so to speak, remained devoted to his artist's spirit, and with a stalwart mission stayed true to his artistic vision while simultaneously driving his art into the demanding teeth of the contemporary world. Change comes with great risk, but Stout has confronted these challenges with sprezzatura, making such difficult tasks appear simple and intrinsic to his very being.

Thomas McEvilley's seminal essay published in conjunction with an exhibition at the artist's home in the spring of 2004 alludes to Stout's consistency over the decades, regardless of stylistic shifts and postmodern explorations, stating that his early works show the traits of "a gentle worker willing to live through the implications of each stage of a process without rushing pell-mell onward."[2] This is a significant observation and important to understanding Stout's current body of work, which certainly evolved out of the pictorial language and trajectory of his early modernist explorations. In this sense, Stout's career is an opera and not a single chorus—you must understand his beginnings in order to fully experience the masterpieces of his present output. Although Stout is often classified as a modernist artist, renowned for his abstract expressionist works of the 1950s and 1960s, his more recent paintings and sculptures, from the late 1990s and early 2000s through the present, show, arguably, the artist's most magnificent and prodigious period. This period, in an aesthetic, formal, and iconographical context, pays homage to his early works and is a visual, contemporary treatise for this retrospective analysis. Philosophically speaking, his recent works are culminations of where he has been, where he is, and where he is going—they represent "this always questing artist's greatest surge of discovery."[3]

Stout's continued success points not only to his adept qualities as an artist but also to his lucid and theoretical understanding of place and home. This idea is evidenced through an examination of both Stout's artistic output and his way of life. Over the past few years, a new exhibition venture appears in Stout's repertoire, adding to his already lengthy and impressive museum and gallery representations—that of shows curated by the artist in his home on Bonnie Brae Street in the Montrose neighborhood of Houston. The artist curated the first house show of his artwork in 1997, which was followed by house exhibitions every two years beginning in 2000 through 2014.[4] These exhibitions fall in line with "pop-up-style" gallery shows currently in vogue, which historically salute

the widely known French salons of the early seventeenth and eighteenth centuries. Such settings give patrons the elusive and often envied opportunity to "see" and converse with artists in their most intimate of habitats—a treat sometimes granted to only the most privileged gallery owners and museum directors and curators—that of their home. The mystical artist is now part of the normal world, surrounded by such mundane objects as a bed, magazine, lamp, and coffee pot. During the early 2000s, Stout's studio was in the backyard, behind his home, thus giving his guests the occasion to see not only where he lives but also where he creates. While some artists produce art for the purpose of an exhibition slotted years down the road, Stout's salon-style home exhibitions provided him the opportunity to instantly present his most recent paintings and sculptures on a time line he set and in a manner he felt most suitable to their subject and significance—their place in his home.[5] It is important to note that these salons were not a substitution for gallery and museum shows—an examination of the artist's biography attests to the continued interest of such art world staples in his work—they were purely a way to connect with his patron on a more intimate, domestic, and intrinsic level, making his philosophical sense of being and place that is the foundation of his art and life also part of his exhibition and curatorial practice. Stout published a catalogue or exhibition brochure in conjunction with every home show, often featuring an exhibition checklist with color images of selected works on view, as well as a scholarly, critical essay written by a historian or art critic.[6]

A sense of home resonates throughout Stout's lifestyle and is the underlying force that ties his oeuvre, spanning more than fifty years, together with the work produced in recent years, which shows astounding vision and understanding of place. The artist has always cited his upbringing in Beaumont, Texas, time spent along the Gulf of Mexico, Bolivar Peninsula, and at his family fishing shack at Rollover Bay as sources of inspiration for his work—this is a subject source that relates the work of earlier decades to the present day. Throughout his career he goes back to these locales as sources for inspiration in his landscapes, seascapes, and numerous interior scenes of rooms and homes inhabited by the artist and his loved ones. Susie Kalil's insightful exhibition catalogue essay discusses the significance of Stout's interior and domestic scenes of the 1990s as views into the artist's psyche, family, and memories.[7] Many of these interiors, such as *When I Was Young* (1991) and *To Thebes* (1995), are beautiful reveries to a bygone time emblazoned in the artist's mind. Stout's emphasis on the memory of his adolescent and mature interiors, both from his point of view and through the eyes of others, gains even more significance when one considers his later salon-style exhibitions held in his home. The artist's literal home, whether referencing his childhood home in Beaumont, current home on Bonnie Brae in Houston, or his family's fishing shack at Rollover Bay, or his metaphorical "home" and place where he feels most at peace, looking out across the vivid and sublime sunrises and sunsets of Galveston Bay and watching the comforting, yet foreboding, waves of the Gulf, are a resounding influence on his career. All echo with memories and are a constant fuel for his brush.

Water is both a subject, a sense of inspiration, and a home for Stout. His painting *Damascus Gate* (1997) shows a Romantic ocean with a sfumato haze, alluding to a distant horizon and expanse of ocean only viewers privy to frequent coastal views will understand. The architectural frame places viewers in an interior, either

of a type of framework for a home or window inside a home, where they look out across the seascape of Stout's mind. The frame gives viewers a specific vantage point but also simultaneously offers a sense of mystery and unease at what is beyond the window and vista we contemplate. This surreal and fearful concept of beauty is Stout's Romantic experimentation with the sublime, which is a dominant undertone in his work created over the past twenty years. Paintings such as *The Citadel* (1997) similarly give the viewer a sense of physical place in an architectural pierlike formation pushing out from the bottom left of the composition, which seemingly offers a path that abruptly ends, dropping off and dissolving into the depths of the Gulf. The dark tones of the pier give way to a shining, ethereal light in the distant horizon, iconographically symbolizing the search for truth and meaning beyond the current, physical state and Stout's ultimate emphasis and philosophical treatise on the transcendent nature of the sea that he envisions. These paintings combine his earlier architectural interior scenes of home with his metaphorical home on the Gulf and serve as a visual path to understanding the transcendent and sublime beauty of life and the sea.[8]

In his widely quoted treatise on the sublime, Edmund Burke states, "The mind of man possesses a sort of creative power of its own; either in representing at pleasure the images of things in the order and manner in which they were received by the senses, or in combining those images in a new manner, and according to a different order. This power is called imagination."[9] This philosophical concept is significant to Stout's recent work and helps us understand the relationship of paintings such as *Night Fishing* (2004) and *Headlands* (2012) to his overall oeuvre. Both paintings, along with others from the past decade, exhibit

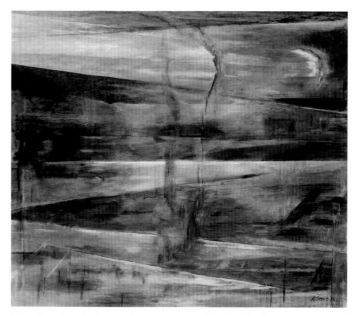

Headlands, 2012, acrylic on canvas, 60 × 70 inches. Courtesy of the artist.

a studied brilliance in color, compositional bravura, dominance, and energy attainable only to someone who knows the specific source and place of their origin. The Texas coast and surrounding vista are as much Stout's home as the bed in which he rests each night. As Burke theorizes, Stout has processed his memories and what he knows—his home on the coast—into highly original and creative visual masterpieces as perceived by his senses that are synergistic in their sublime beauty and transcendent thought. There are no people in these paintings, but a sense of presence and being, intrinsic to the artist who created them, resonates throughout the compositions. This is seen, in particular, in *Headlands*, which features a red wisp floating off into the distant and mysterious depths of the ominous ocean. According to Stout, this wisp is symbolic of the "spirit leaving this life for the final journey" and speaks to the very essence of humanity.[10]

His immense masterpiece *A Day at Rollover Bay*

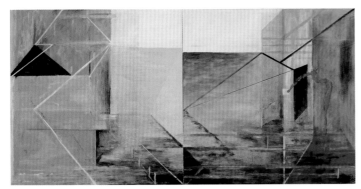

A Day at Rollover Bay, 2015, acrylic on canvas, 30 × 60 inches. Collection of Richard Stout, Houston.

(2015) also refers to the presence of people, not literally but metaphorically, in the passing of time and day in the visual narrative played out across the composition. The painting reads from left to right like a continuous narrative, giving a panoramic view of Stout's surroundings at Rollover Bay, a location frequented by the artist since his adolescent days. Much like Monet (1840–1926) in his famous series on Rouen Cathedral, Stout shows the passing and observation of time and impact of light on the bay in the shift from light to dark and pastel to vibrant hues as the clouds and sun play over the fleeting moment. This painting, similar to *Damascus Gate*, *The Citadel*, and *Night Fishing*, includes architectural elements seen in the geometric lines intersecting, dividing, and interweaving throughout the composition. The dark and ominous window feature to the far right gives off a sense of longing and uncertainty of what the future holds, emphasizing the sublime undertones of the work.

One of Stout's most recent paintings, *The Way* (2016), shows the culmination of these ideas, incorporating a dark and foreboding structure with bursts of blue and red in the foreground, architectural elements, and a horizon line that doubles as the structure's roof with beams of light that call to mind the artist's

coastal motifs. An abstract interpretation of a church, including a steeple that pierces the dark sky, portrays the power and resolute strength of light in the darkness. Metaphorically, the church and prominent steeple serve as a beacon of light, much like a lighthouse, for wayward ships and lost souls out at sea, searching for a path to understanding and enlightenment. Stout paints dark, obscured windows across the facade of the building and an undefined foreground, which gives a surreal essence and visually symbolizes a quest for stability in chaos.

The visual metaphors in *The Way* resonate in Stout's existence, in his artistic philosophy, and throughout his oeuvre. He has searched, over the years, for something more than mere physical, human experience—a transcendent exploration that only a willing spirit will seek and find. His devotion to the sea and Texas coast, which he states is "infinite and fraught," is one of reverence and admiration, expressing his understanding and fear of the unknown with a desire to seek, thus offering a constant source for artistic inspiration.[11] Through fervent exploration, a voracious and insatiable desire for education, an open mind and vir-

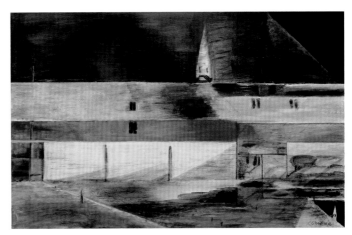

The Way, 2016, acrylic on canvas, 30 × 48 inches. Collection of Richard Stout, Houston.

tuosic spirit, Stout has cultivated a pictorial vocabulary and curated a holistic life that reaches into the depths of his soul, his true being, and resonates in this place he calls home.

Illustrations of the artwork discussed in this essay can be viewed in the gallery as images 7, 27, 28, 34, and 54–59.

Notes

1. See the essays in this book by Katie Robinson Edwards and Mark White for a thorough examination of Stout's early career and place in the great art historical climate of the period. Also see the biography section for Stout's selected exhibition history and résumé; note the consistent amount of exhibitions since the early 2000s.

2. Thomas McEvilley, *Richard Stout: Approaching the Limits of Space* (Houston: Richard Stout, publisher, 2004), 7 [exhibition catalogue].

3. Ibid., 11.

4. Richard Stout, e-mail message to author, December 8, 2016. Stout stated that his first home show was in the winter of 1997 and was occasioned by his departure from Barbara Davis Gallery in Houston.

5. See the essay in this book by Jim Edwards for an analysis of Stout's three-dimensional work.

6. McEvilley's *Richard Stout: Approaching the Limits of Space* is one such catalogue, published by Stout for his 2004 home exhibition.

7. Susie Kalil, *Richard Stout: Soul's Journey* (Beaumont: Art Museum of Southeast Texas, 1999) [exhibition catalogue].

8. McEvilley's *Richard Stout: Approaching the Limits of Space* gives a thorough analysis of Stout's more recent work in relation to the sublime and transcendental philosophy.

9. Edmund Burke, "Introduction: On Taste," in *A Philosophical Inquiry into the Origin of Our Ideas of the Sublime and Beautiful, with an Introductory Discourse concerning Taste, and Several Other Additions*, 6th ed. (London: 1770), https://ebooks.adelaide.edu.au/b/burke/edmund/sublime/introduction.html.

10. Richard Stout, e-mail message to author, December 8, 2016.

11. Ibid.

THE TOPOGRAPHY OF INTIMATE BEING

Mark White

Children form often profound and indelible attachments to place in ways that shape their perception of other environments for the remainder of their lives. Home is not only where the heart is, but also the mind, in many respects. It might be argued that artists, in particular, are responsive to the specifics of such places, or what writer Don Gayton has called the primal landscape, and, despite whatever influences they pick up during their education, that primal landscape remains a vital part of the ego.[1]

For Richard Stout, the coastal environment of southeastern Texas and its attendant culture have anchored much of his career. An earnest topophilia permeates Stout's oeuvre, not only in his attachment to landscape but also in his adoration of domestic spaces. Though many of his paintings depict physical locations, his concern has been neither a representation of appearance nor likeness but the poetic image, which Gaston Bachelard asserts "has an entity and a dynamism of its own; it is referable to a direct ontology."[2] Stout's images, in a sense, live as ruminations on the contiguous topography of being, memory, and place. Various influences from abstract expressionism and tachisme, French intimism, neoexpressionism, and metaphysical painting have shaped how he has expressed those meditations over time but only as

an exploration of alternative paths to the same destination.

Prior to Stout's formal training, the aspiring artist looked to his own Beaumont home for inspiration with one of his earliest extant paintings, *The Den* (1952). The room usually serves as a quiet, secluded refuge for family, but the absence of figures is unsettling and explained partly by the death of Stout's father, Charles, the previous year. Richard's mother, Bess Lauderdale Stout, would come to play an increasingly important role in his life and career in coming years, though her presence in his work is largely implied by the orderly domestic environment. A lengthy runner anchors the space and leads the eye to the door frame on the far wall with its ornamental pediment that lends a hallowed character to the setting. Stout, in recent years, has come to think of that central path to the door as a metaphorical Via Dolorosa, leading ultimately to martyrdom and resurrection.[3] In this respect, the family home becomes a locus for creative transfiguration, and *The Den*, specifically, joins the domestic with the spiritual. *The Den* hints at Stout's development of a topography of intimate being, a projection of the psyche rich in personal associations, where the memories of the past, thoughts of the present, and even the possibilities of the future merge.[4]

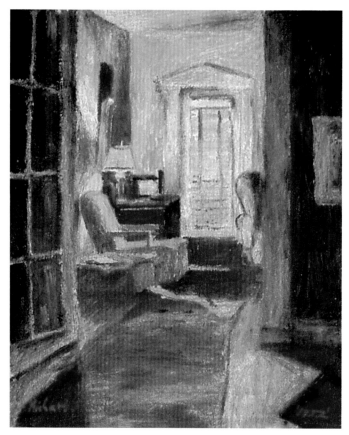

The Den, 1952, oil on canvas, 18 × 24 inches. Collection of Richard Stout, Houston.

age him to embrace action painting. *Cave* and *The West Wind* (formerly titled *God*), both from 1957, the year Stout would return to the Gulf Coast from Chicago, demonstrate a thorough understanding of the improvisational, fluid approach of the gesture. In *Cave*, the large canvas seems insufficient to contain the expansive composition that extends ostensibly past the painting's physical limit. The prismatic palette and chaotic brushwork create a nebulous, subterranean enclosure. Stout's title suggests a hidden, secluded space uneasily explored and potentially unlimited in its network of tunnels, shafts, and courses.

The expansive space implied in *Cave* became a familiar trope among abstract artists working in the American Southwest. The wide-open spaces of that corner of the United States prompted in artists of the region considerations of immensity and vastness, as

Stout's image of the family home would shape his career in the decades to come, most prominently in later paintings from the 1980s and 1990s, and his study at the School of the Art Institute of Chicago provided him additional means of exploring his primal landscape. He began his education in 1953 with instructors that included Isobel Steele MacKinnon (1896–1971), Paul Wieghardt (1897–1969), and Kathleen Blackshear (1897–1988), the latter of whom gave him a thorough grounding in art history. Important examples of abstract expressionism, such as Willem de Kooning's (1904–1997) *Excavation* (1950) and Jackson Pollock's (1912–1956) *Greyed Rainbow* (1953), would encour-

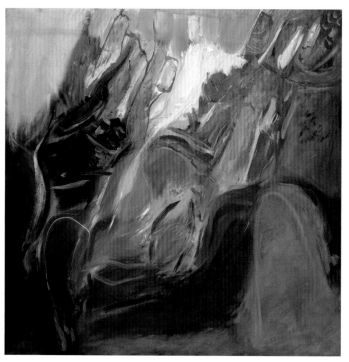

Cave (triptych), 1957, oil on canvas, 50 × 50 inches. The Summers Collection, Austin.

well as a concomitant introspection. Stout shared a common sensibility with colleagues in Texas, Colorado, New Mexico, and Oklahoma, all of whom used the language of abstract expressionism to depict at once the enormity of the region and the specificity of their immediate surroundings, conflating macrocosmic and microcosmic space in a single composition. Though space was a conceptual issue that engaged midcentury abstract artists in both the New York school and the San Francisco Bay Area, artists in the Southwest, including Stout, responded to the dynamic space of the region in a thoroughly idiosyncratic manner, sympathetic but distinct from what occurred on the East and West Coasts.[5]

In Stout's *The West Wind*, the horizontality of the painting could suggest an infinite stretch though restricts the energy to an eddy of brushstrokes off center. The luminous palette glows with what seems an interior radiance, furthering the theistic implications of the former title, yet *The West Wind*, in its overall character, shares less with the tradition of religious imagery than it does with marine painting. During his education, Stout came to revere the work of John Marin (1870–1953), whose watercolors reportedly influenced the development of abstract expressionism, and the diagonals and swirls of *The West Wind* infer tidal movements. Stout's home, not the house but the local environment of the Gulf Coast, reasserted itself in his paintings and would lead to a body of work in which water figures prominently. Marin and numerous other artists before him, like Albert Pinkham Ryder (1847–1917), Fitz Hugh Lane (1804–1865), and Martin Johnson Heade (1819–1904), also associated water with the divine, or with spirituality in a less defined sense, and Stout signaled his intention to join that venerable tradition with *The West Wind*.[6]

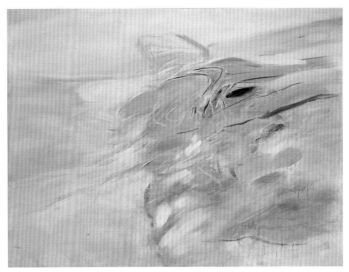

God (The West Wind), oil on canvas, 60 × 81 inches. Collection of Jason Aigner and Mrs. Mary Aigner, Houston.

Following Stout's return to southeastern Texas in 1957, the wave motif became more pronounced in his work. *To Robert Duncan* (1960) pays homage to the eponymous poet and his poem *The Song of the Border-guard* (1952), published at Black Mountain College with a linocut cover printed by Cy Twombly (1928–2011). The heavy symbolism of the poem celebrates the creative act as an alternative to violence and aggression and situates the poet or artist as an advocate for change. In the shadow of an escalating Vietnam conflict, it is little surprise that Stout might be drawn to thoughts of both peace and resistance. The painting is dominated by a sweep of impasto analogous to a cresting wave, set against a stained murky stretch of gray and green and a vaguely defined landform. The style owes much to the direction initiated in *The West Wind* but also demonstrates the raw, heavy application of paint comparable to that of French painter Nicolas de Staël (1914–1955), whom Stout had seen at the Museum of Fine Arts, Houston (MFAH) in the early 1960s. Despite the influence of de Staël

and his brand of tachisme, the forms of the painting in their flux and intangibility allude to a "distant, perhaps unattainable, future," a reference not only to the uncertainty of the political climate of 1960 but also to Stout's bittersweet attachment to the Gulf region and its strange inscrutable quality: "The bay isn't pleasant and the water isn't pretty, but it's always changing—the weather, the clouds, the light. You feel vulnerable, isolated, exposed. The sea has always possessed a searching quality for me."[7] The Gulf, as synonymous with home as the Stouts' Beaumont house, transcends easy explication but is inextricably linked to Stout's ruminations on being. *To Robert Duncan* and other paintings of that period act, in part, as the artist's attempt to grapple with both the space and his own intimate attachment to it.

Stout eventually gave his copy of the Duncan poem to his brother-in-law, Paul Winkler, who was Twombly's close friend and eventually the director at the Menil Collection. The artist met his future wife, Anne Winkler, at a lecture at the University of

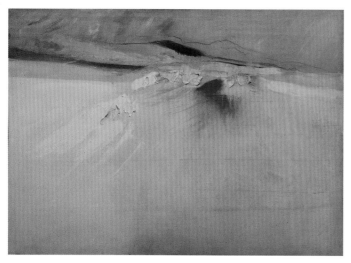

To Robert Duncan, 1960, oil on canvas, 46¼ × 64¾ inches. Collection of Fred Jones Jr. Museum of Art, the University of Oklahoma, Norman; Acquisition.

St. Thomas in 1965, a decade that would be an auspicious time in his career. He became part of a vital contemporary art community in Houston that included artists Jack W. Boynton (1928–2010), Dorothy Hood (1919–2000), Jim Love (1927–2005), and Dick Wray (1933–2011). Collectors John and Dominique de Menil actively supported modern art and had lured scholar Jermayne MacAgy from San Francisco in 1955 to direct the Contemporary Arts Association. In 1961, James Johnson Sweeney, formerly director of the Solomon R. Guggenheim Museum, was appointed director of the MFAH. Houston also satisfied Stout's desire for a home with innovative architecture, a personal interest hinted at in *The Den* and visible in his later works. For example, Mies van der Rohe's (1886–1969) Cullinan Hall was commissioned by the MFAH in 1953 and opened in 1958. Philip Johnson (1906–2005), having already designed a home for the Menils, completed the first of his expansions for the campus of St. Thomas in 1958.[8]

As if in response to the architectural transformation of Houston in the 1960s, Stout's paintings came to depend more on geometry. In *Green Moonrise* (1963), the wave motif persists but is balanced by a subtle geometry, not only in the arc of the rising moon and emphatic horizon but also in the vertical bands of black and white. The expressive tidal forms create a diagonal leading directly to or from the horizon, as though a path to be followed. Thomas McEvilley has characterized *Green Moonrise* and the paintings that follow as transcendental, with trails and courses that "hew out a way through the world—or, later, a way out of it, or both in and out."[9] The search for transcendence in the natural world strengthens Stout's association with artists such as Heade, Lane, and Ryder and suggests a closer parallel with fellow Gulf Coast resi-

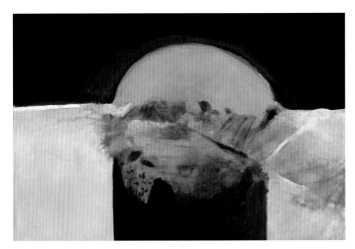

Green Moonrise, 1963, oil on canvas, 36 × 53 inches. Collection of Richard Stout, Houston.

dent Forrest Bess (1911–1977). The alternating bands and insistent horizon of *Green Moonrise* compare subtly to Bess's *Untitled (No. 11A)* (1958; MFAH), a visionary image that had some relation to the coast despite its more complex symbolism.[10] However, Stout maintained a murkier, more somber atmosphere than Bess, one that persists throughout the former's career.

Geometry and precision came to dominate Stout's paintings in the late 1960s and early 1970s. During his graduate study in 1966–1967 at the University of Texas at Austin, he developed a series of pyramidal compositions, the origin of which was an oblique response to Mordor in J. R. R. Tolkien's *The Lord of the Rings*. A series of hard-edged symmetrical compositions followed, all of which anticipated his return to architectural subjects in the mid-1980s.

By the late 1970s, Stout made a return to gestural abstraction, but with an approach decidedly different from that in his work from the 1950s and 1960s. His works were the subject of a successful one-man exhibition at Houston's Contemporary Arts Museum in 1973. In 1975, his monumental painting *For Heroes* was juried as First Prize at the annual Houston area exhibition at the Blaffer Gallery.

He began visiting West Germany in the mid-1970s and was drawn to Düsseldorf, which was one of the leading centers of contemporary art in West Germany. Both Joseph Beuys (1921–1986) and Gerhard Richter (born 1932), for example, taught at the Kunstakademie Düsseldorf during the 1970s, and Stout was encouraged by the "freedom of process" espoused there. The American admired Richter's abstract paintings, exhibited in the city during that time, as well as those of Georg Baselitz (born 1938), whose exhibit at the European Kunsthalle in Cologne Stout saw in 1976.[11] The examples of Richter and Baselitz, in addition to that of the German minimalists ZERO Gruppe, prompted Stout to focus on materiality and a crude, almost rudimentary handling of paint. His *Dusseldorf* (1977), with its discordant palette, splatters, and violent strokes of paint, departs significantly from his previous work. He eschewed both representational elements and geometric structure in favor of informality and a lack of finish.

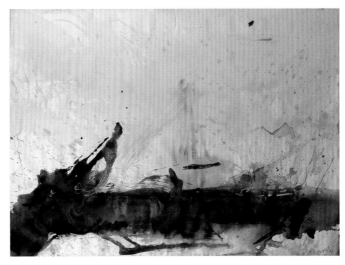

Dusseldorf, 1977, mixed media on paper, 31 × 42 inches. Collection of Richard Stout, Houston.

Stout then translated this new approach to a subject closer to home in *Rose City* (1977). With a similar palette and seemingly unrefined application of paint, *Rose City* refers to William Goyen's 1974 novel *Come, the Restorer* and the fictional town of Rose, Texas, which suffers from debilitating cultural and environmental changes caused by the oil industry. Rampant greed and profiteering have left Rose a shadow of its former self, but a savior in the form of Mr. de Persia brings momentary hope to the residents with his ability to restore old photographs and hence some of the fading life of the town. Mr. de Persia is the figurative artist whose talents promise revitalization and even resurrection, though the damage can never be reversed entirely. He restores the past to the present, at least momentarily, and renews the spiritual and sexual vitality of a dying town.[12] *Rose City*, too, celebrates creative, unrestrained vigor with its broad cascades of paint that arc downward across the canvas, but the painting also serves as a condemnation of the voracious excesses of an oil industry that had entirely transformed the Gulf Coast of Stout's childhood. *Rose City*, and many of Stout's paintings to follow, express a sense of loss similar to that in Goyen's writing. The landscape of the Gulf Coast and fragments of the family home summon haunting recollections of an irretrievable past. Memory, as conceived in Stout's paintings as well as Goyen's novels, colors the present, fostering a sense of unreality.

During his frequent trips to West Germany, Stout faced a period of uncertainty and lack of clarity in his work. His wife, Anne, was hospitalized in 1980 and 1982, and he abandoned the materiality of *Rose City* and *Dusseldorf* for a brief flirtation with figuration. A range of disparate influences, including fifth-century Greek sculpture, the metaphysical paintings of Giorgio de Chirico (1888–1978), and the neoexpressionist

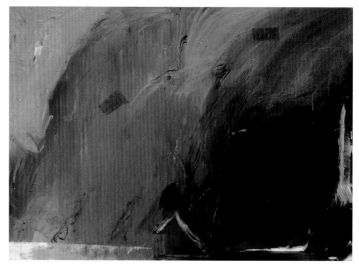

Rose City, 1977, acrylic on canvas, 75 × 100 × 2½ inches. The Museum of Fine Arts, Houston, Gift of Toni and Jeffery Beauchamp, 2008.245 © Richard Stout.

works of A. R. Penck (born 1939), merged in his *Oedipus* (1972–1984). Penck had created a series of works on the Oedipus myth in recent years, prompting Stout's investigation of the theme, and Stout altered a previous painting from 1972, turning the orientation vertically and filling it with biomorphic forms and fragments of antique sculpture. Apart from the influence of Penck, the title is a clear reference to the mythological hero and king who fulfills prophecy by unwittingly slaying his father, King Laius, and marrying his mother, Queen Jocasta. His mother commits suicide, and Oedipus, on learning the truth, blinds himself with pins from his mother's garment. Sigmund Freud's theory of the Oedipal complex in childhood development often overshadows the import of the myth, and Stout was less concerned with psychoanalytic thought than the tragic potential of the future. Troubled by the precarious nature of Anne's health, he sacrificed an earlier painting, obscuring a portion of his artistic past, to cope with the anxiety of the present.

Following Anne's death in 1985, Stout took refuge in sites of deep personal significance: the Houston home he shared with Anne on Bonnie Brae, his mother's home in Beaumont, and the family fishing shack at Rollover Bay on Bolivar Peninsula. Two examples from 1985, *Bolivar Roads* and *Waiting for God*, reflect Stout's personal sensibilities and focus during this time.

Later works such as *Ancestors in Charcoal* (1990) and *My Father's Room* (1993), both of which depict the Beaumont home, echo the character of *The Den* in the emphasis on domestic architecture and memory. A strong sense of representation resurfaced in his images of domestic architecture, spurred not only by a reassessment of his youthful efforts but also by his lifelong interest in Pierre Bonnard (1867–1947). While studying at the School of the Art Institute of Chicago in the 1950s, Stout admired the pallid colors, feathery brushwork, and emotional intimacy of Bonnard's domestic scene, particularly the museum's *Still Life*:

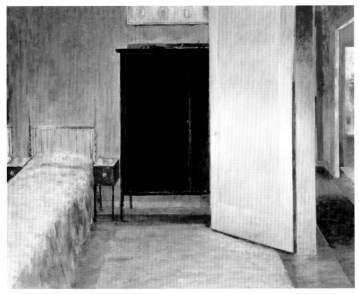

My Father's Room, 1993, acrylic on canvas, 40 × 50 inches. Collection of Richard Stout, Houston.

Preparation for Lunch (1940).[13] Whereas Bonnard's wife, Marthe de Méligny (Maria Boursin), often dominated the painter's compositions, Stout's paintings of this period lack human presence, resulting in a feeling of vague disaffection.

The unreality and estrangement of Stout's paintings of the 1990s became more acute as he began to dissemble architecture and sites of personal significance into fragments, only to rejoin them in fantastic oneiric settings. Largely dependent on a potent mixture of contemporary experience and recent and distant memories, his landscapes are set at an indeterminate time that seems at once dawn, midday, twilight, and evening. Similarly, the customary dialectics of inside and outside, closed and open, and here and there collapse in paintings such as *Gibraltar* (1995), in which the waters of the Gulf have invaded a desolate cityscape composed of disjointed facades and monumental stairways. A dilapidated pier at lower right only contributes to the inexplicable character of the scene. Stout's admiration for Bonnard is still evident in the palette but mediated by the enigmatic spaces of de Chirico, Yasuo Kuniyoshi (1893–1953), and Edwin Dickinson (1891–1978), whose *Ruin at Daphne* (1943–1953; Metropolitan Museum of Art, New York) almost provides a precedent for Stout's new environments.

Gibraltar also recalls an action painting from 1957, which provides some indication of Stout's reflective mood in the 1990s. Past, present, and future coalesce with sites from his intimate topography to form other poetic images, such as *The East Wall* (1997), in which the interior space joins with the Gulf Coast. The pier in the midground, somewhat indistinct in *Gibraltar*, attains greater significance as a site of interaction with the water. The detritus of the coast becomes more

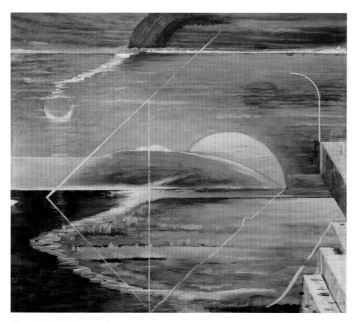

Oracle, 2008, acrylic on canvas, 60 × 70 inches.
Collection of Richard Stout, Houston.

pronounced in subsequent paintings from the 2000s. Both *Morning* (2005) and *Oracle* (2008) derive from the built environment of the coast, yet bridges, levees, and piers become abstract elements that define, contain, and structure the water and land. Although *Morning* is somewhat explicable in its abstract forms, *Oracle* unites multiple images of the Gulf, coastal infrastructure, and mysterious terrestrial and celestial bodies to evoke some unfathomable future. *Oracle* draws together many of the motifs from Stout's career in a single image, as though a compendium of his artistic vocabulary. The painting's elements recall at once the abstracted tidal movements of *The West Wind* and *To Robert Duncan*, the lunar motif of *Green Moonrise*, and the cascade of *Rose City*, while continuing the aesthetic trajectory of recent works such as *Gibraltar* and *Morning*. Stout's artistic past informs the present and foreshadows a melancholic future in *Oracle*.

The cryptic geometry of *Oracle*, derived from the coastal infrastructure pictured in *Morning* yet divorced from any clearly recognizable source, evades clear meaning. Although the ideogram may have secret meaning to the artist, it is unknowable for the viewer and exists outside a common frame of reference. Just as Stout could never fully articulate the emotions, memories, and personal associations that shape his relationship to place, his poetic images defy interpretation or discernment at times.[14]

Ambiguity persists in Stout's recent work *Midnight Fishing* (2014), despite its descriptive title. Three indistinct masses of sky, land, and water provide the setting for an inexplicable architecture, complete with ghostly forms reminiscent of sails, flags, or even beams of light. The nocturnal allusions of *Oracle* are more fully realized in the dusky *Midnight Fishing* and compare closely with Albert Pinkham Ryder's mysterious nocturnes. The painting transcends the purely descriptive and hints at something beyond everyday experience. Like so many of Stout's images of the Gulf, *Midnight Fishing* forms part of his ongoing exploration of place, which is inseparably bound with memory. Despite a direct reference to time, *Midnight Fishing*, like so much of his work, draws deliberately from an intoxicating blend of recollections and emotions that confounds continuity.

Over the course of his career, Stout's exploration of his primal landscape has led him down multiple avenues of expression but ever as a means of realizing visually his inner topography. The artistic and literary influences from which he drew are decidedly varied and offer Stout new ways of contending with his lifelong meditation on place. His poetic images of domestic spaces and coastal landscape echo memories and experiences inextricably bound to his sense of being. For the viewer, the paintings offer new ways to con-

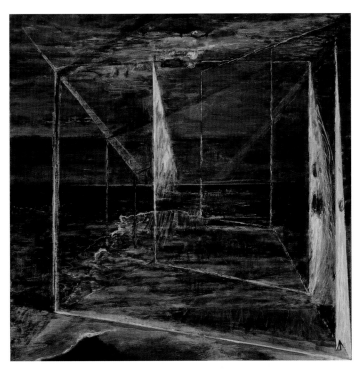

Midnight Fishing, 2014, acrylic on canvas, 30 × 30 inches. Collection of Karen and Neal Epstein, Houston.

sider existing and evolving relationships to spaces of intimacy. Stout challenges the viewer to contemplate with him how that close attachment to place shapes identity.

Illustrations of the artwork discussed in this essay can be viewed in the gallery as images 5, 12, 16, 26, 54, and 60–68.

Notes

1. Don Gayton, *Landscapes of the Interior: Reexplorations of Nature and the Human Spirit* (Gabriola Island, BC: New Society Publishers, 1996).

2. Gaston Bachelard, *The Poetics of Space*, trans. Maria Jolas (New York: Orion Press, 1964), xii.

3. Richard Stout, e-mail message to author, April 27, 2016.

4. Bachelard, *The Poetics of Space*, xxxii. Bachelard insisted that "on whatever theoretical horizon we examine it, the house image would appear to have become the topography of our intimate being." Though he was reticent to use the term "home," he conceived of the house image as inseparably linked to the soul: "Our soul is an abode. And by remembering 'houses' and 'rooms,' we learn to 'abide' within ourselves. Now everything becomes clear, the house images move in both directions: they are in us as much as we are in them" (xxxiii). Stout's paintings function similarly as an evolving ontological dialogue between artist, home, and poetic image.

5. The American Southwest in the 1950s and 1960s became a confluence of influences from the East and West Coasts. Artists such as Elaine de Kooning (1918–1989) visited Amarillo, Texas, and Albuquerque, New Mexico, on a regular basis in the late 1950s, and Bay Area artists Richard Diebenkorn (1922–1993), Edward Corbett (1919–1971), and Clay Spohn (1898–1977) all spent considerable time in New Mexico in the 1950s. Stout was not personally connected to these artists during that time but was part of a fertile environment. For more information on abstract expressionism and its influence in the Southwest, see Mark Andrew White, *Macrocosm/Microcosm: Abstract Expressionism in the American Southwest* (Norman, OK: Fred Jones Jr. Museum of Art, 2014).

6. Scholars have examined the association between

spirituality and American marine painting extensively. Among the first and more venerable studies is Barbara Novak, *American Painting of the Nineteenth Century*: *Realism, Idealism, and the American Experience*, 2nd ed. (New York: Harper and Row, 1979). Also see John Wilmerding, *American Marine Painting*, 2nd ed. (New York: Abrams, 1987). For a further discussion of Marin's relationship to abstract expressionism, see William C. Agee, "John Marin's Greatness: The Late Oils and Post-1945 Art," in *John Marin*: *The Late Oils* (New York: Adelson Galleries, 2008), 5–21; and Debra Bricker Balken, *John Marin*: *Modernism at Midcentury* (New Haven, CT: Yale University Press, 2011).

7. Richard Stout, e-mail message to author, April 27, 2016; and Stout quoted in Susie Kalil, *Richard Stout*: *Soul's Journey* (Beaumont: Art Museum of Southeast Texas, 1999), 10.

8. James W. Boynton, Louise Ferrari, Jim Love, Richard Stout, and Dick Wray, oral history interview by Sandra Curtis, Archives of American Art, November 28, 1979, http://www.aaa.si.edu/collections/interviews/oral-history-interview-james-w-boynton-louise-ferrari-jim-love-rich-ard-stout-and-dick-wray-12521. Stout had little intention of returning to Houston permanently in 1957 but was pleased by the transformation of the city. For a further discussion of the Houston contemporary art scene at midcentury, see Alison de Lima Greene, *Texas*: *150 Works from the Museum of Fine Arts*, *Houston* (New York: Harry N. Abrams, 2000); Katie Robinson Edwards, *Midcentury Modern Art in Texas* (Austin: University of Texas Press, 2014); and White, *Macrocosm/Microcosm*.

9. Thomas McEvilley, *Richard Stout*: *Approaching the Limits of Space* (Houston: Richard Stout, publisher, 2004), 8 [exhibition catalogue].

10. For an expanded discussion of Bess and his work, see Clare Elliott, *Forrest Bess*: *Seeing Things Invisible* (Houston: The Menil Collection, 2013). Bess's complex personal philosophy included interests in immortality, transcendence, and hermaphroditism.

11. For example, Konrad Fischer Galerie hosted the Richter exhibition *Soft Abstracts* from October 22 to November 22.

12. William Goyen, *Come, the Restorer* (Garden City, NY: Doubleday, 1974). Goyen described Mr. de Persia's abilities to restore old photographs as a veritable resurrection: "When he came around he brought back a company of lost people, all before us risen up out of our shoeboxes and cedarchests like ghosts out of their graves. Mr. de Persia resurrected half our town and brought back old times, reviving the dead and renewing the perishing with his magic slight-of-hand (as he called it)" (5). Clark Davis has described Mr. de Persia as a "savior of the pastoral" who can restore nature threatened by abuse. Davis, *It Starts with Trouble*: *William Goyen and the Life of Writing* (Austin: University of Texas Press, 2015), 259.

13. Richard Stout, e-mail message to author, June 3, 2016. Stout was also drawn to Bonnard through his friendship with Robert Natkin, who claimed a strong influence from the French postimpressionist.

14. Bachelard asserts that "the entire life of the image is in its dazzling splendor, in the fact than an image is a transcending of all the premises of sensibility." Bachelard, *The Poetics of Space*, xxix.

GALLERY

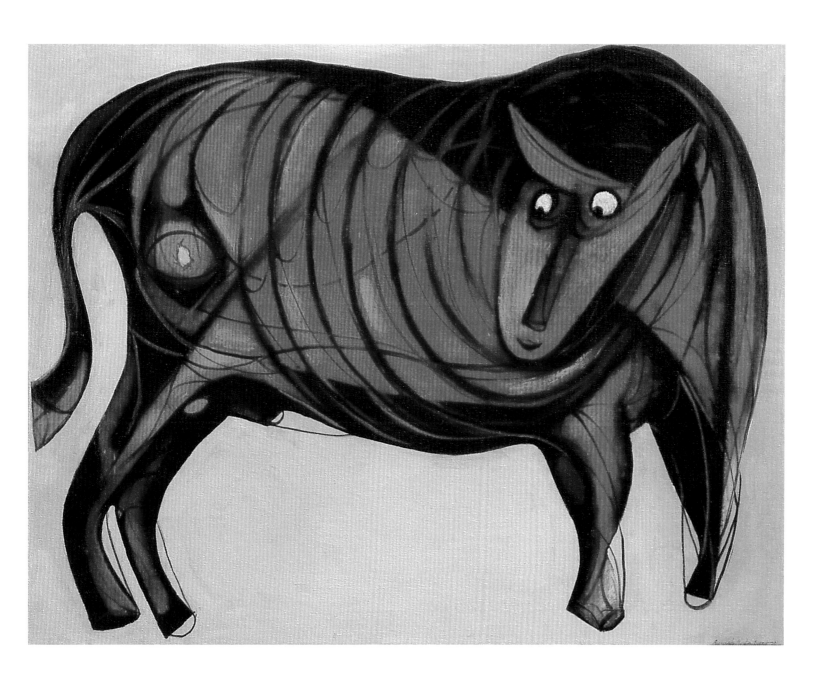

1
Red Bull, 1954, oil on canvas, 26 × 34 inches.
Private Collection, Houston.

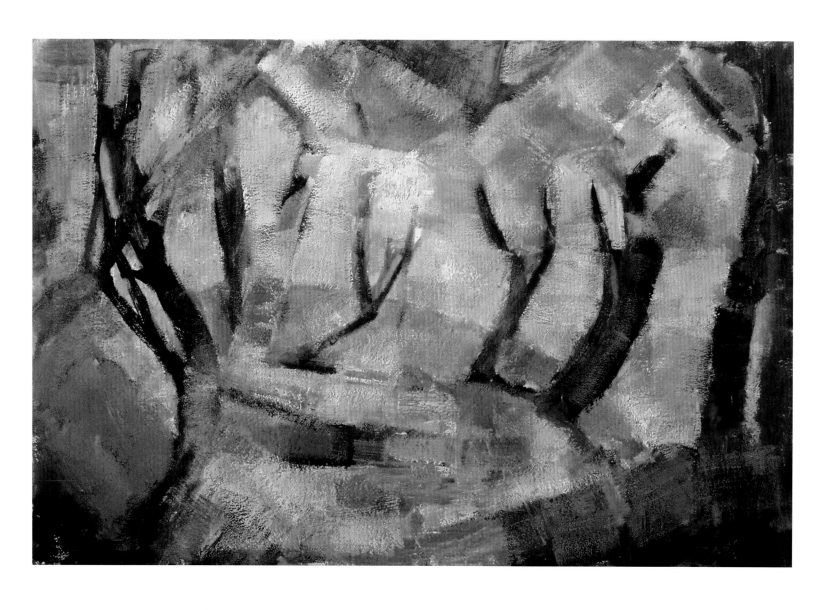

2
Bus Stop at Lincoln Park, 1953, oil on paper, 12 × 18 inches.
Collection of Tom and Tam Kiehnhoff, Houston.

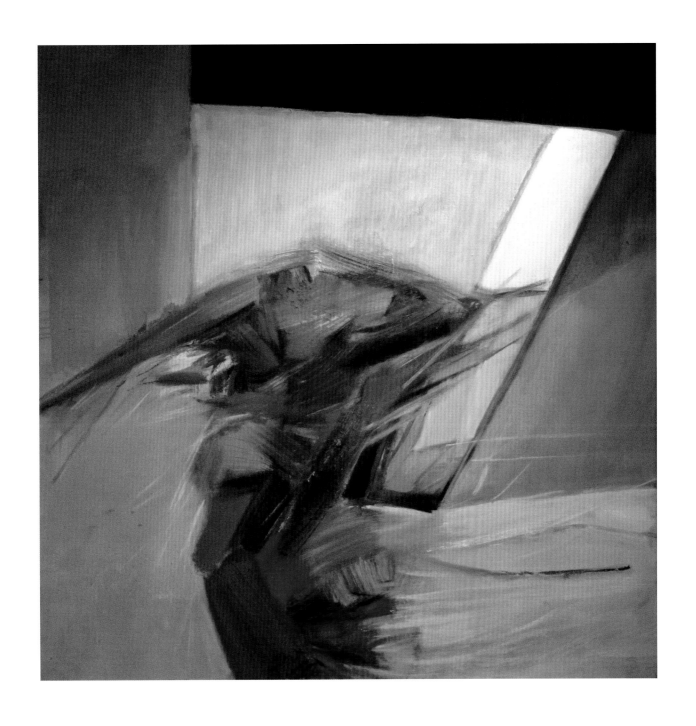

3
Seiche II, 1956, oil on canvas, 50 × 50 inches. Permanent
Collection of the Art Museum of Southeast Texas, Beaumont,
Gift of John Millington, PC2000.02.02.

4
Seiche III, 1956, oil on canvas, 40 × 50 inches.
Collection of Sally and Steve Gaskin, Dallas.

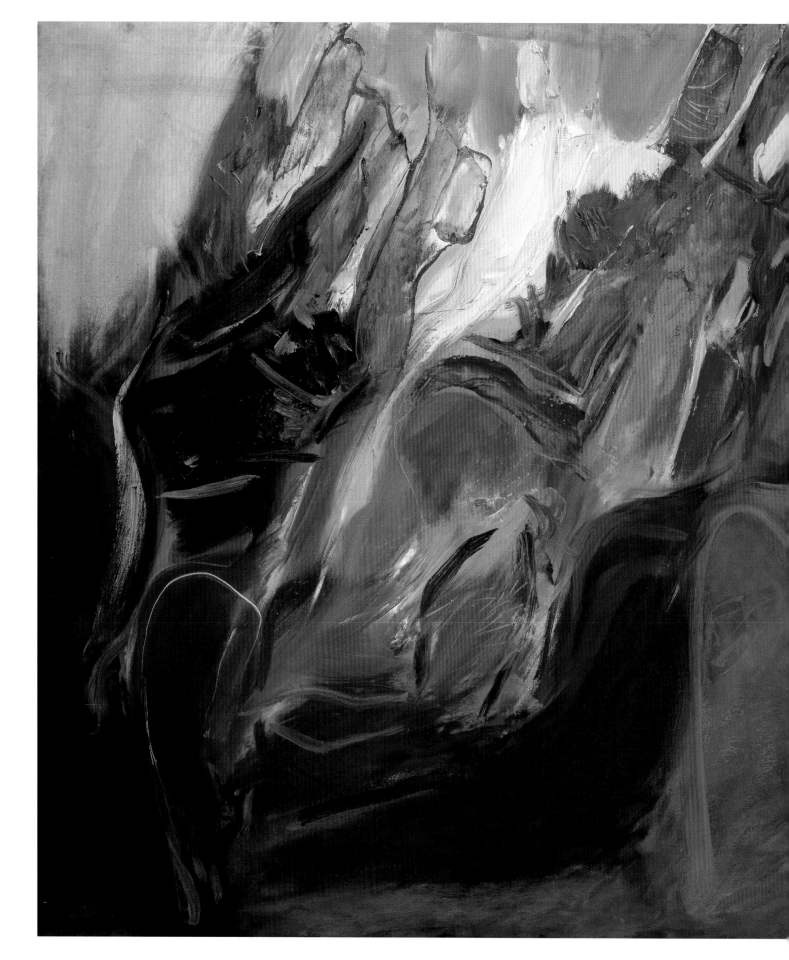

5
Cave (triptych), 1957, oil on canvas, 50 × 50 inches.
The Summers Collection, Austin.

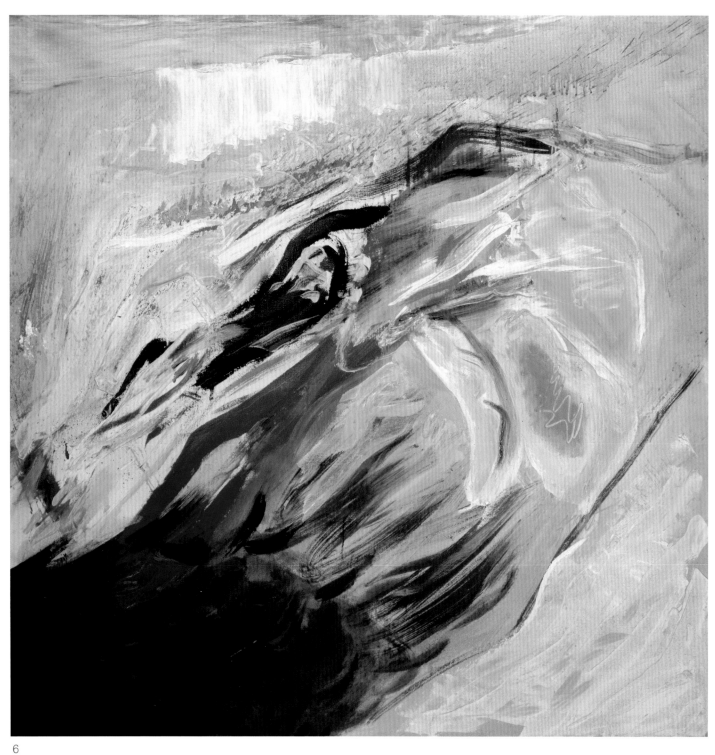

6
Flowers (triptych), 1957, oil on canvas, 50 × 50 inches.
Private Collection, Houston.

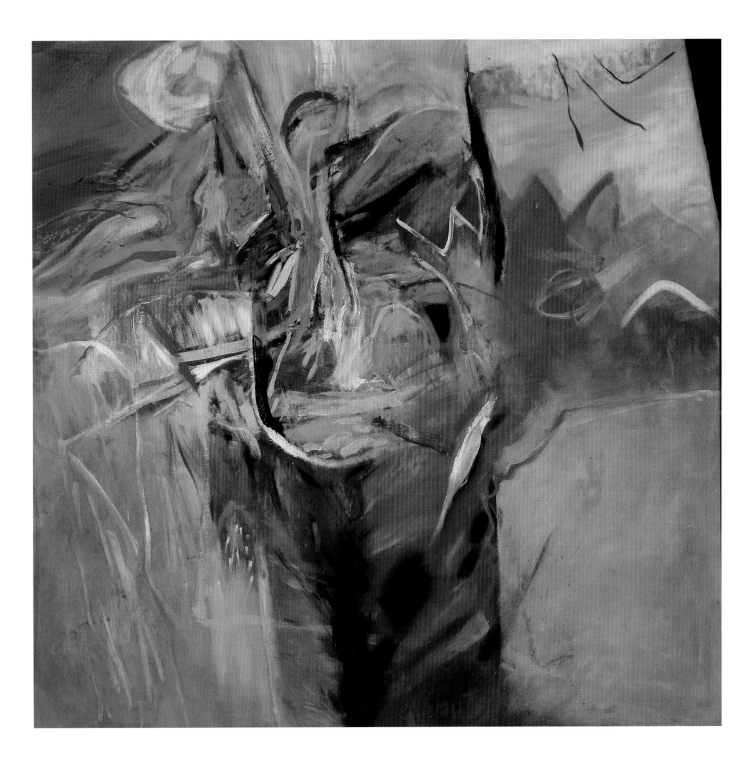

7
Passion (triptych), 1957, oil on canvas, 71 × 74 inches.
Collection of David Ellis, Fort Worth.

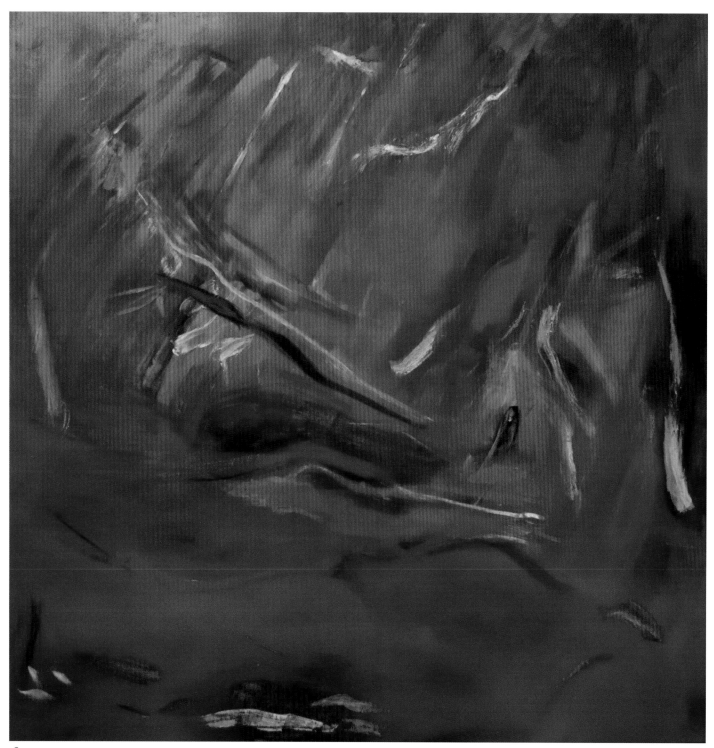

8
Untitled (red painting), 1957, oil on canvas, 68 × 68 inches.
Collection of Lias J. Steen, Houston.

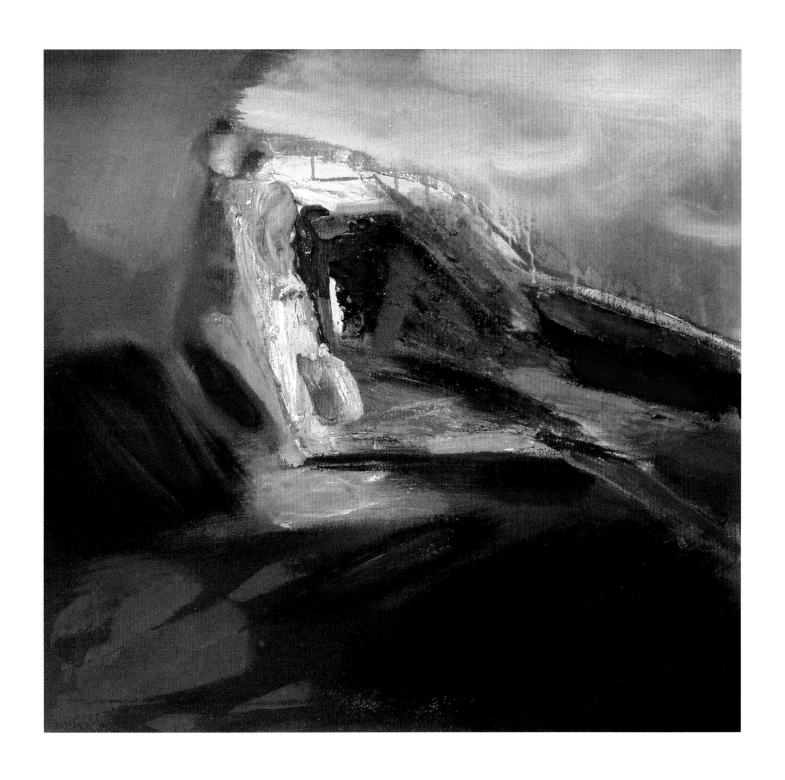

9
Blue Gibraltar, 1957, oil on canvas, 30 × 32 inches. Collection of
Randy Tibbits and Rick Bebermeyer, Houston.

10
I Went Down to the Sea,
1959, oil on canvas, 16 × 30
inches. Collection of Heartland
Security Insurance Group,
Tyler.

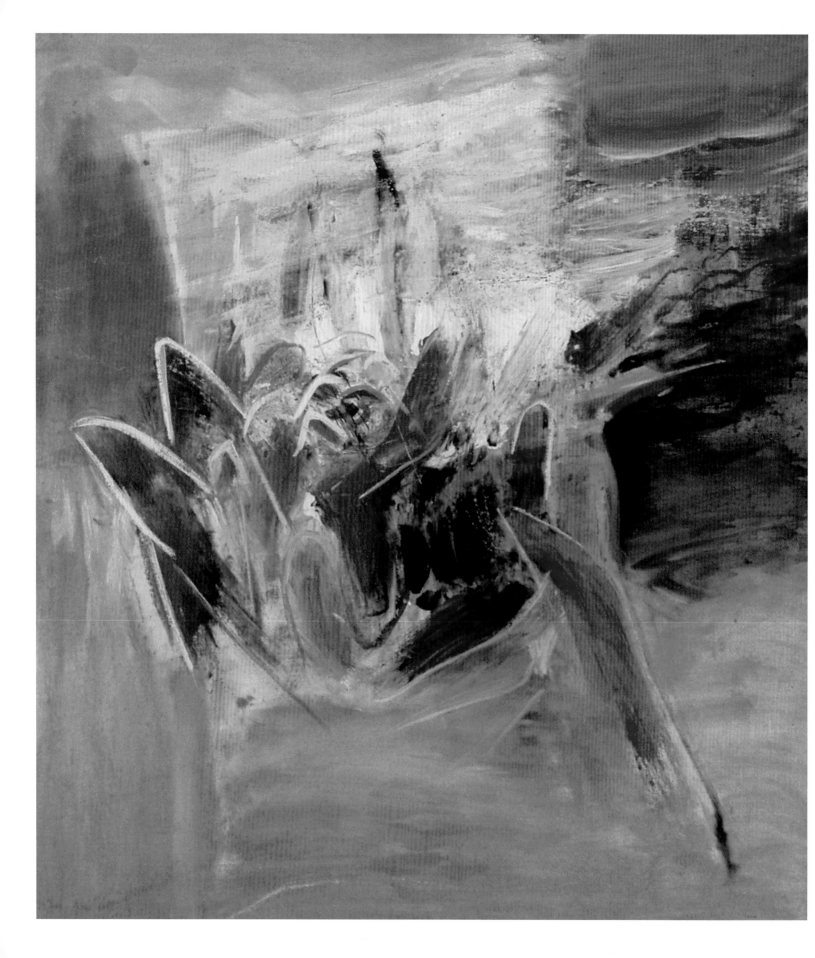

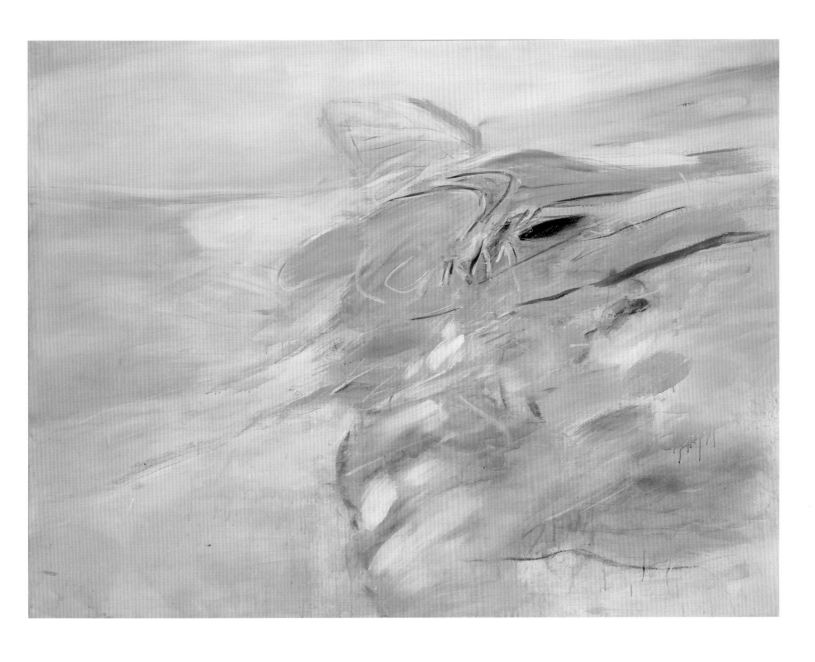

11
(left) *Nest*, 1958, oil on canvas, 43.5 × 39 inches.
Collection of Randy Tibbits and Rick Bebermeyer, Houston.

12
(above) *God (The West Wind)*, 1957, oil on canvas, 60 × 81
inches. Collection of Jason Aigner and Mrs. Mary Aigner,
Houston.

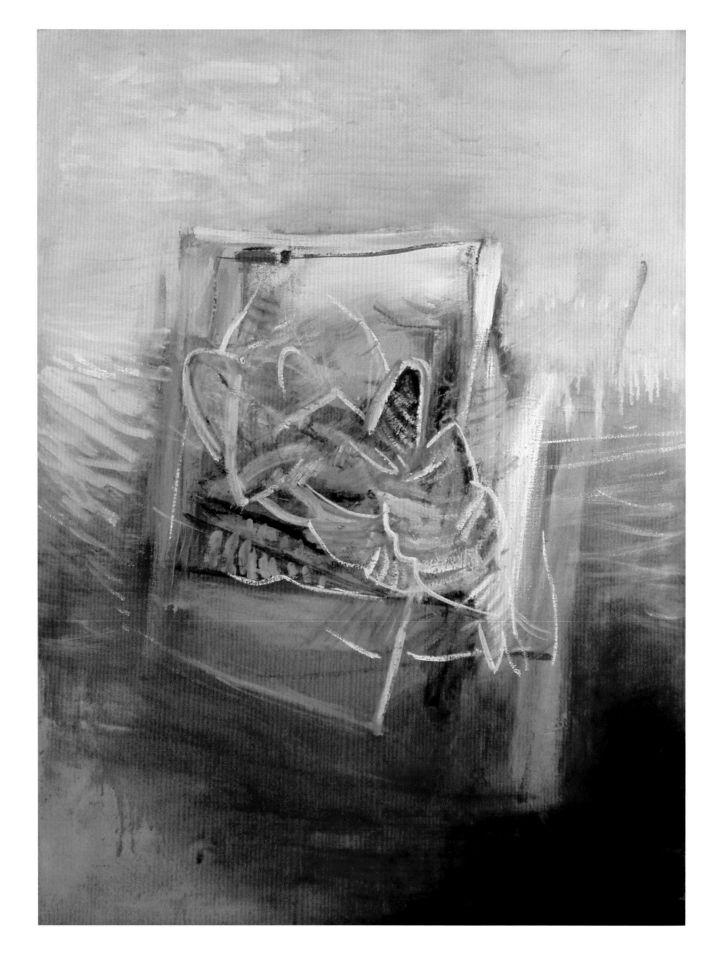

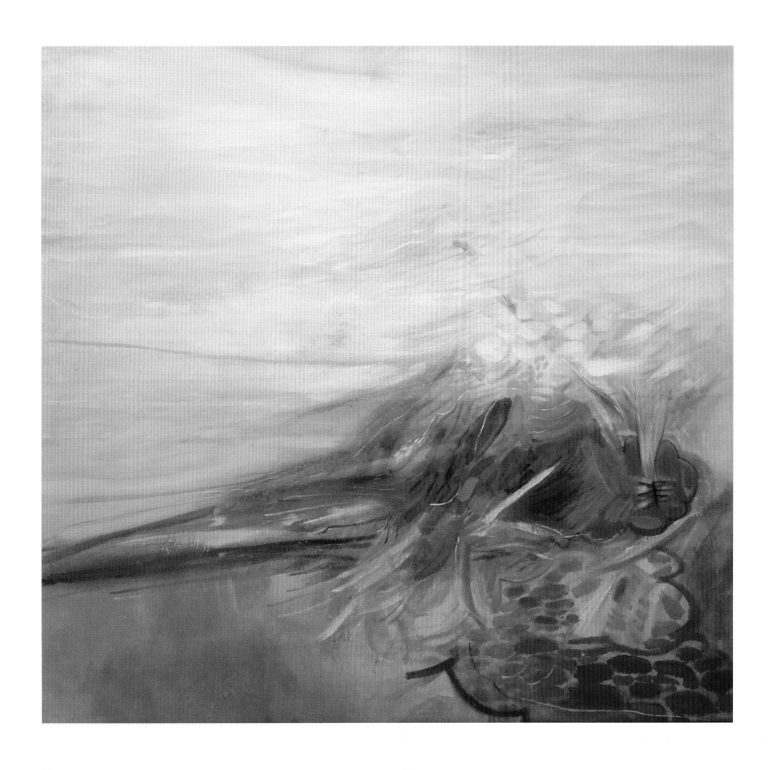

13
(left) *Love Nest*, 1958, oil on canvas, 47 × 35 inches.
Courtesy of the artist.

14
(above) *Resurrection*, 1958, oil on canvas, 67 × 69 inches.
Collection of Bobbie and John L. Nau, Houston

59

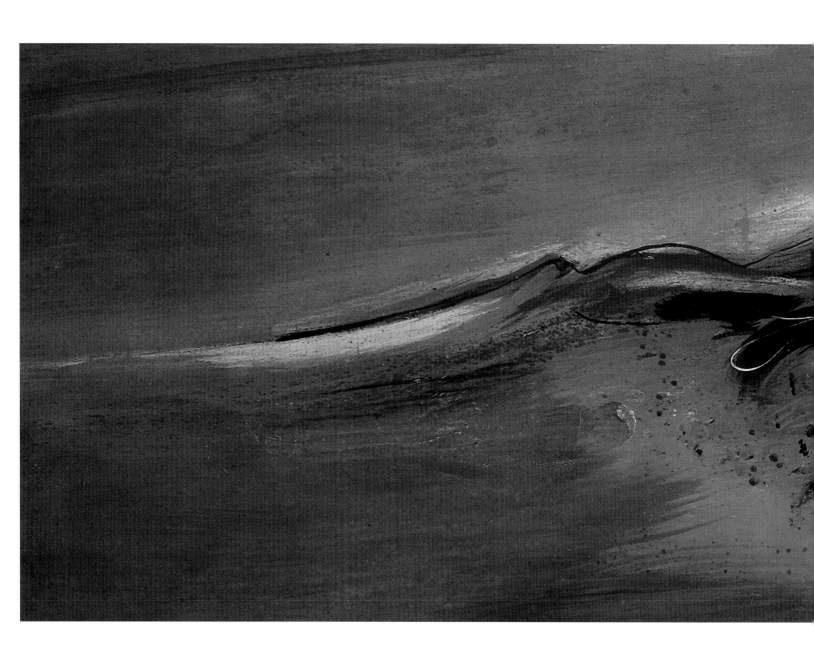

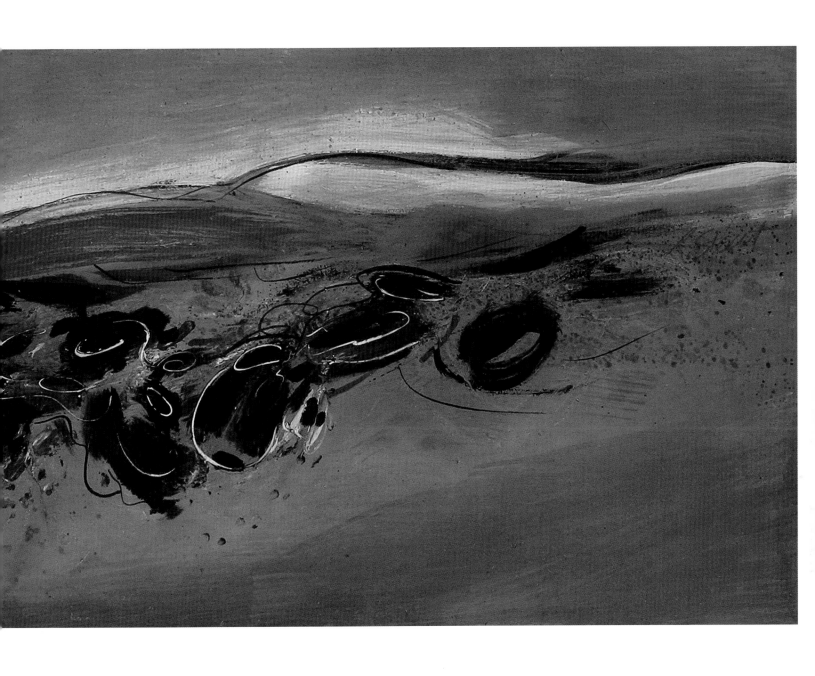

15
The Black Wave, 1959, oil on canvas, 23 × 69 inches.
Collection of Charles M. Peveto, Austin.

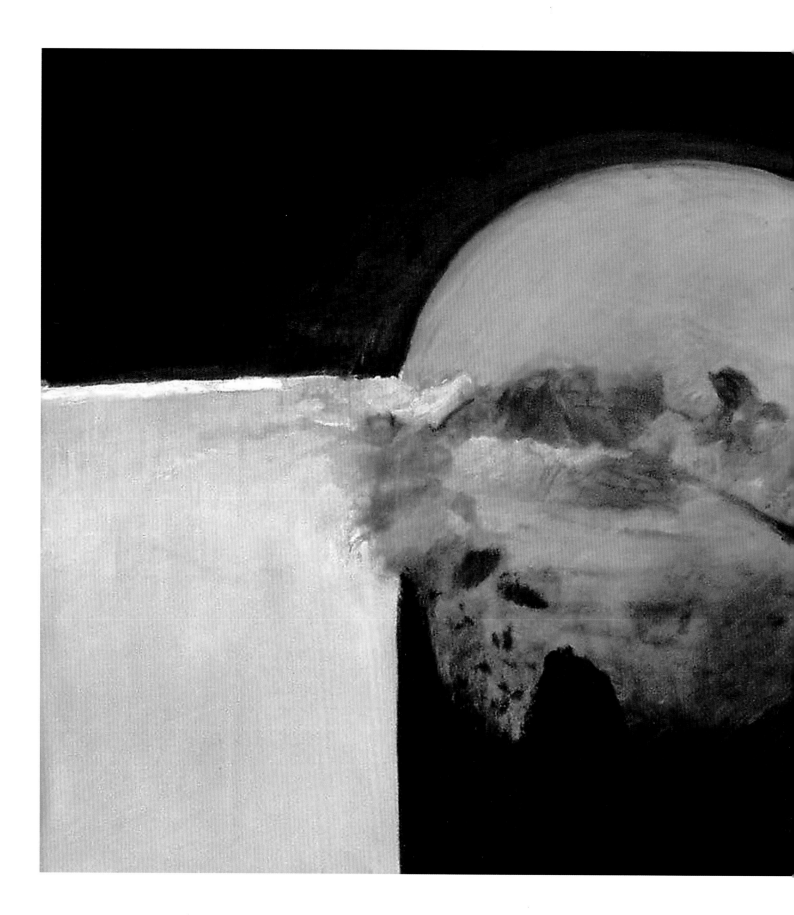

16
Green Moonrise, 1963, oil on canvas, 36 × 53 inches.
Collection of Richard Stout, Houston.

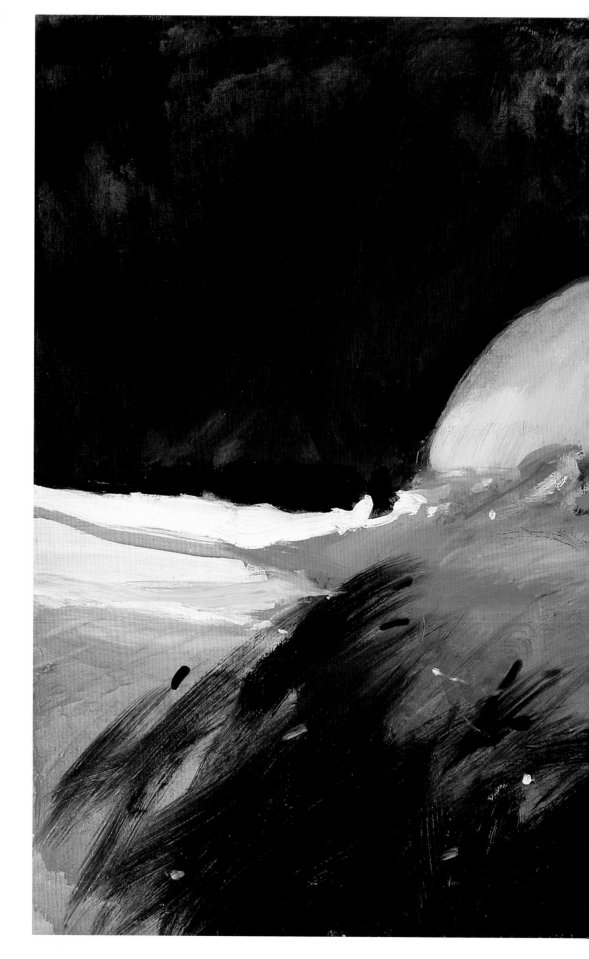

17
Blue Dome, 1964, oil on
canvas, 26 × 40 inches.
Collection of Carole and
Jim Kilpatrick, Houston.

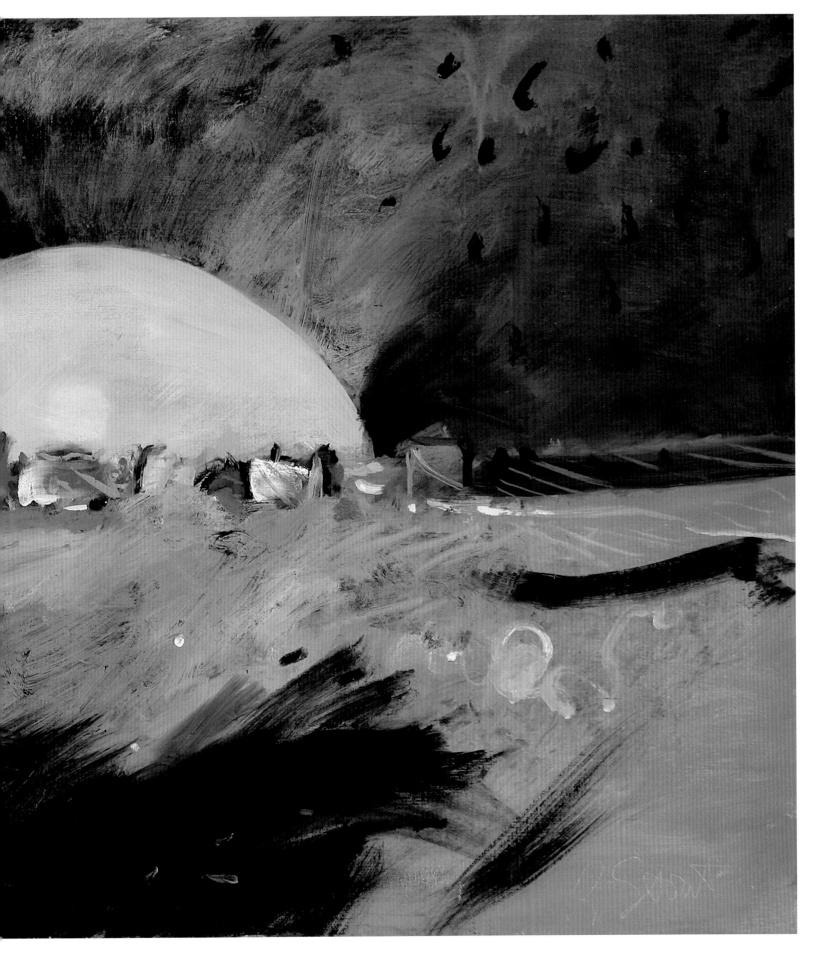

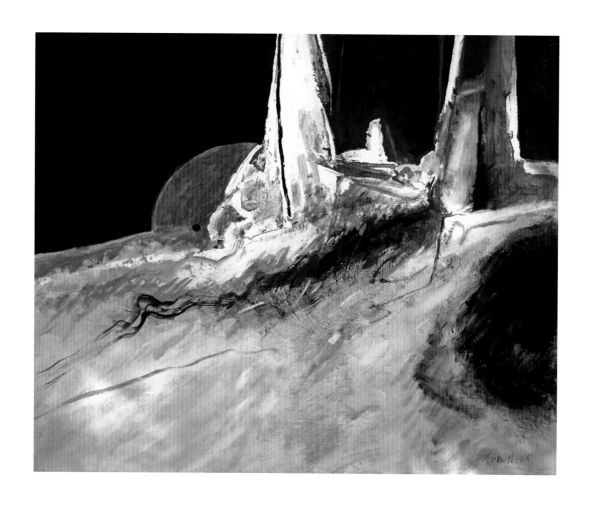

18
(above) *Gantries*, 1965, acrylic on canvas, 18 × 24 inches.
Collection of Kirk Baxter and David Waller, Houston.

19
(right) *Time after Time*, 1962, oil on canvas, 70 × 52 inches.
Collection of Richard Stout, Houston.

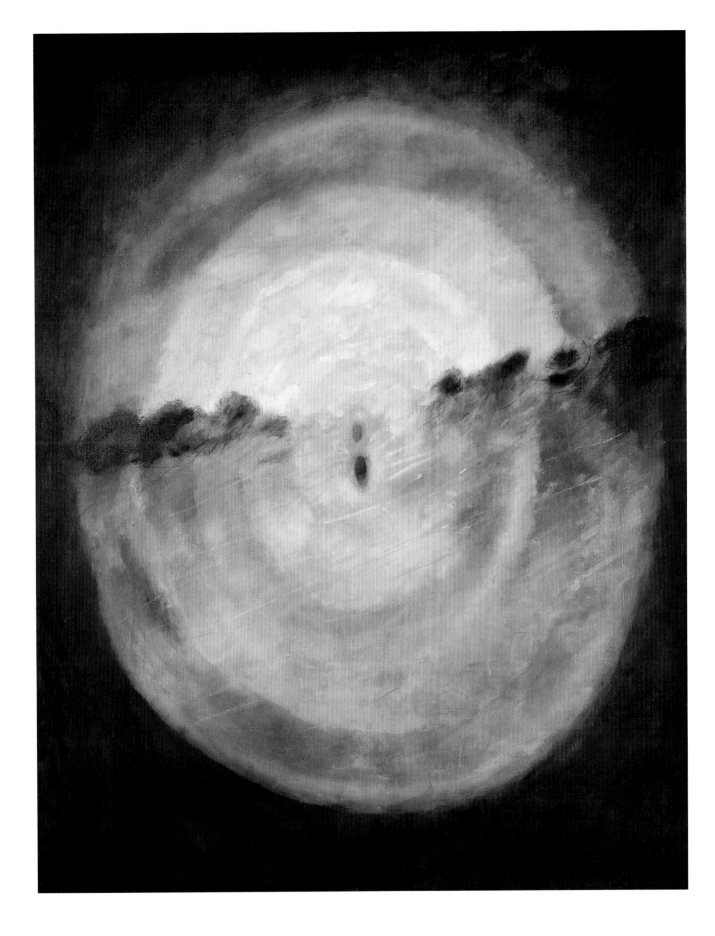

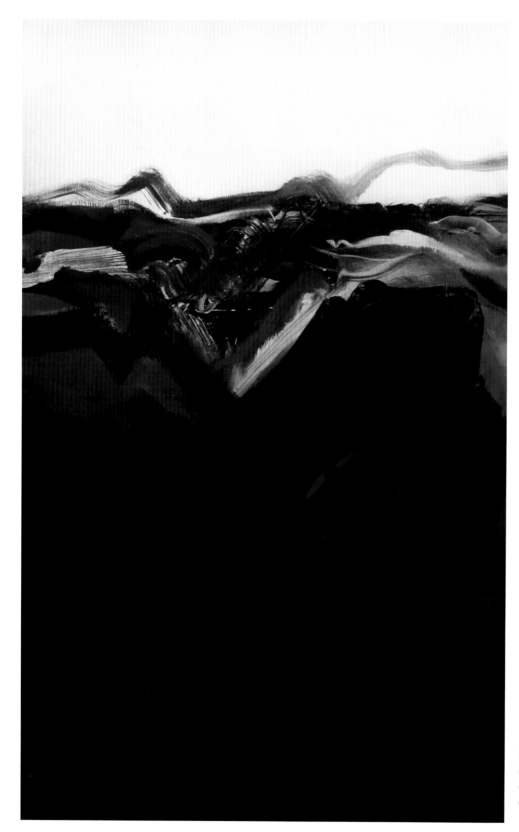

20
(left) *December*, 1961, oil
on canvas, 60 × 38 inches.
Collection of Jason Aigner and
Mrs. Mary Aigner, Houston.

21
(right) *Remembrance*, 1961, oil on
canvas, 66 × 48 inches. Collection
of Dianne Yeomans, Houston.

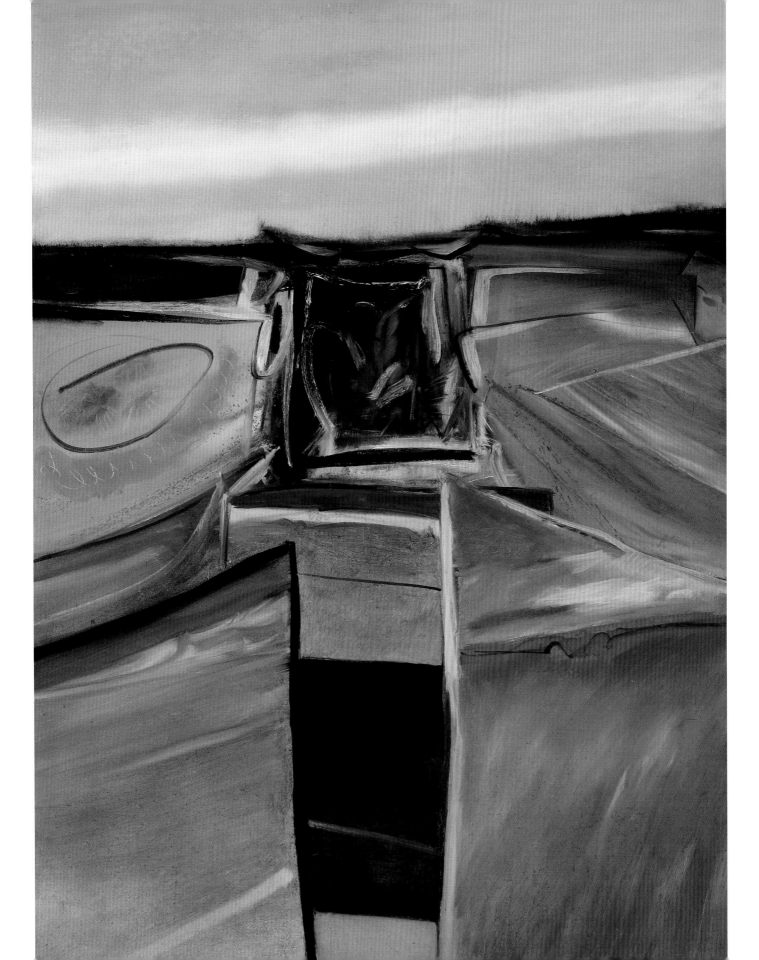

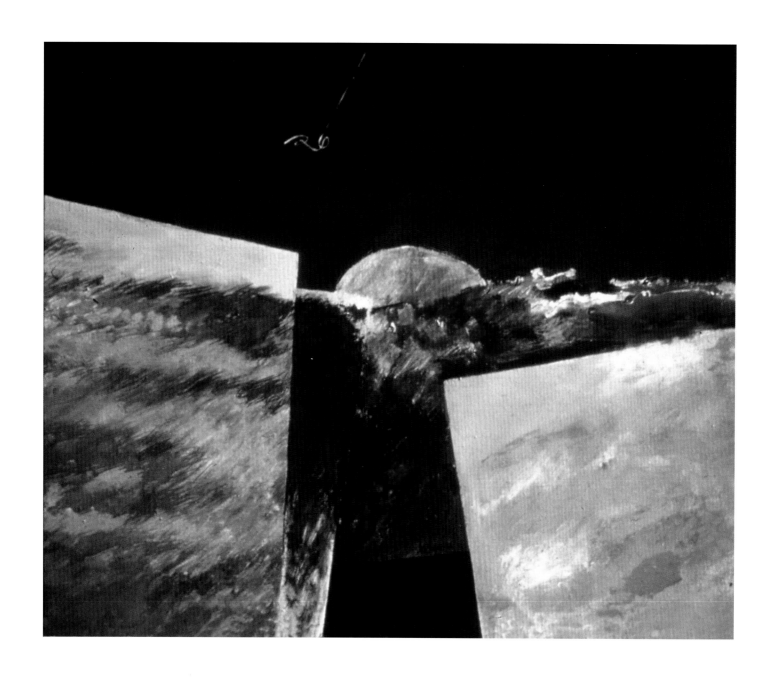

22
SS Sweeney, 1968, oil on canvas, 50× 60 inches.
Courtesy of the artist.

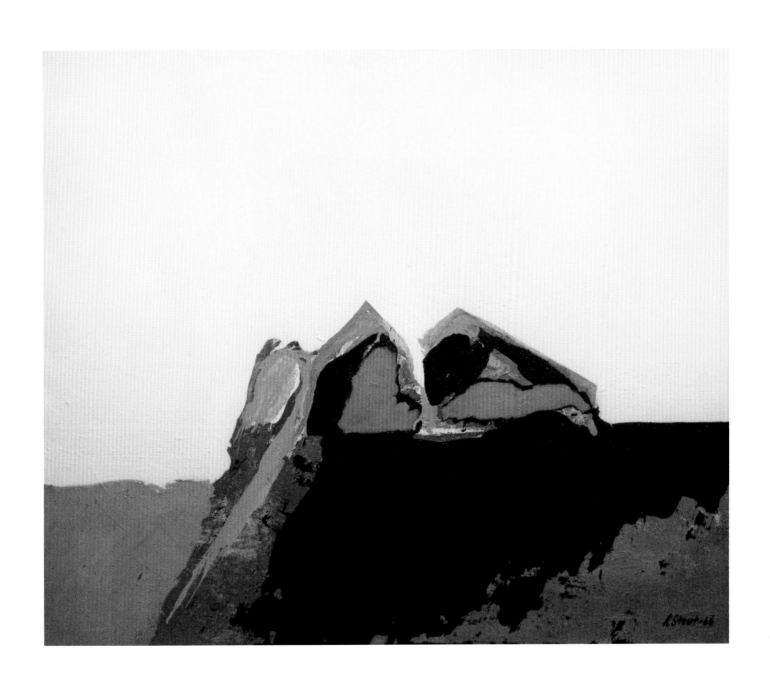

23
Home, 1966, oil on canvas, 30 × 40 inches.
Collection of Richard Stout, Houston.

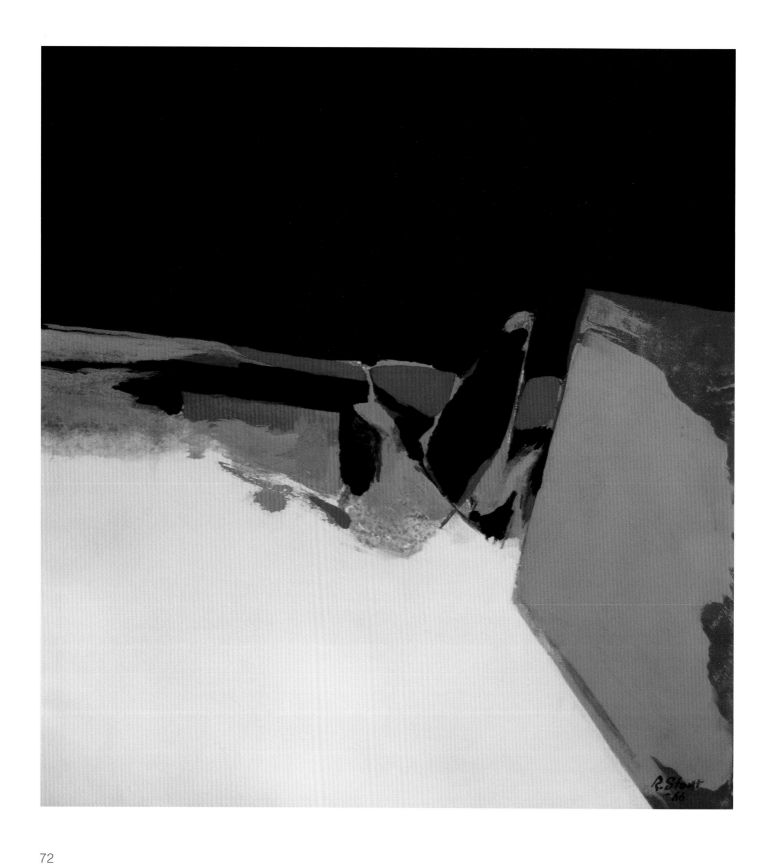

72

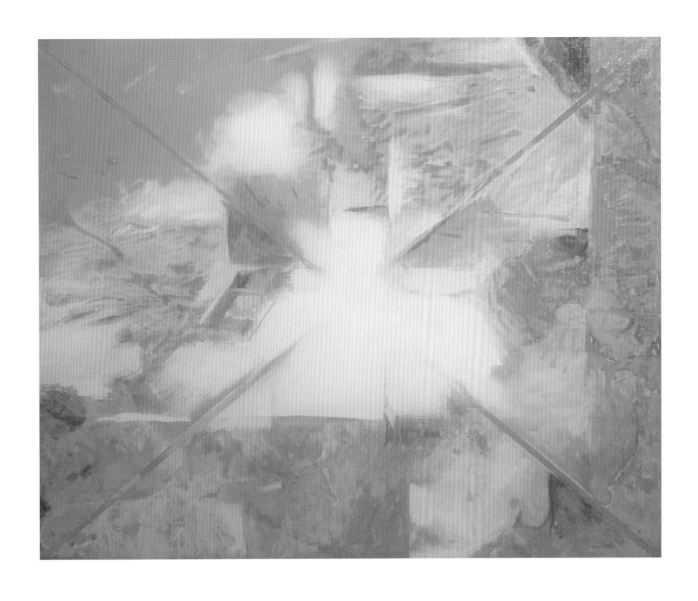

24

(left) *Hamlet*, 1966, oil on canvas, 36 × 34 inches.
Collection of Richard Stout, Houston.

25

(above) *Houston*, 1972, acrylic on canvas, 40 × 48 inches.
Collection of Sharmilia Anandasabapathy and
Andrew Sikora, Houston.

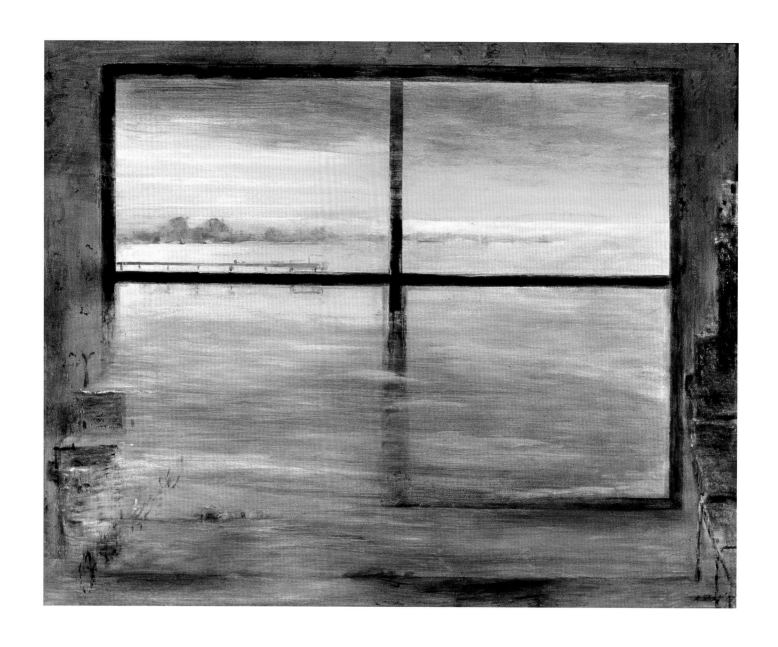

26
The East Wall, 1997, acrylic on canvas, 40 × 50 inches.
Collection of Adelaide Biggs, Houston.

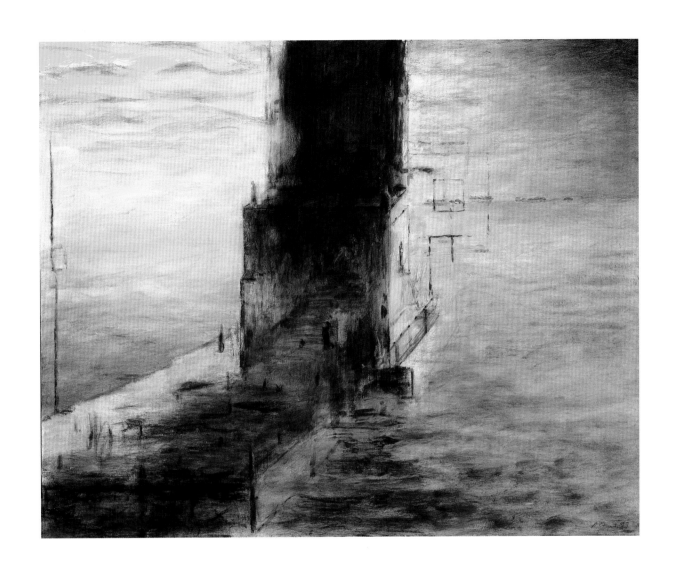

27
The Citadel, 1997, acrylic on canvas, 50 × 62 inches.
Collection of Tara Lewis and John Swords, Dallas.

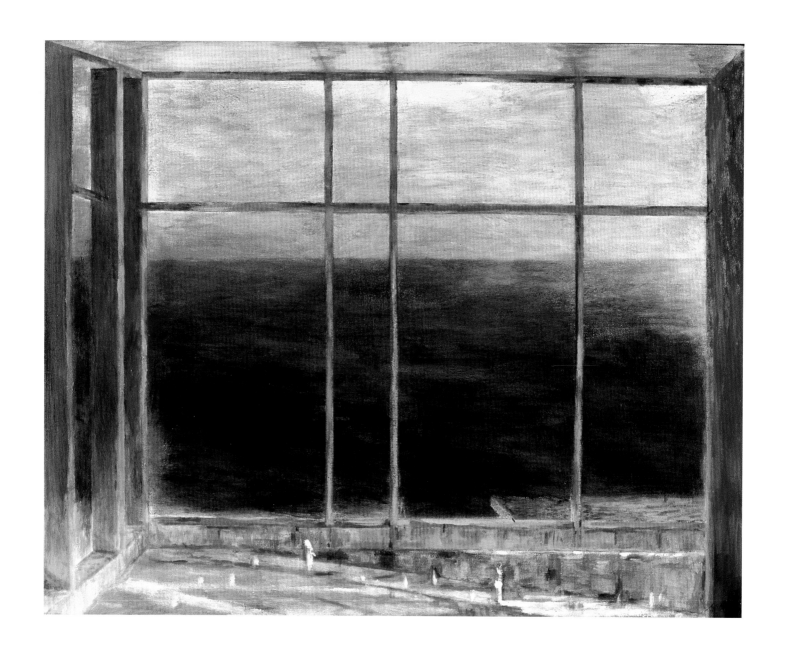

28
Damascus Gate, 1997, acrylic on canvas, 40 × 50 inches.
Collection of Lenni and Bill Burke, Houston.

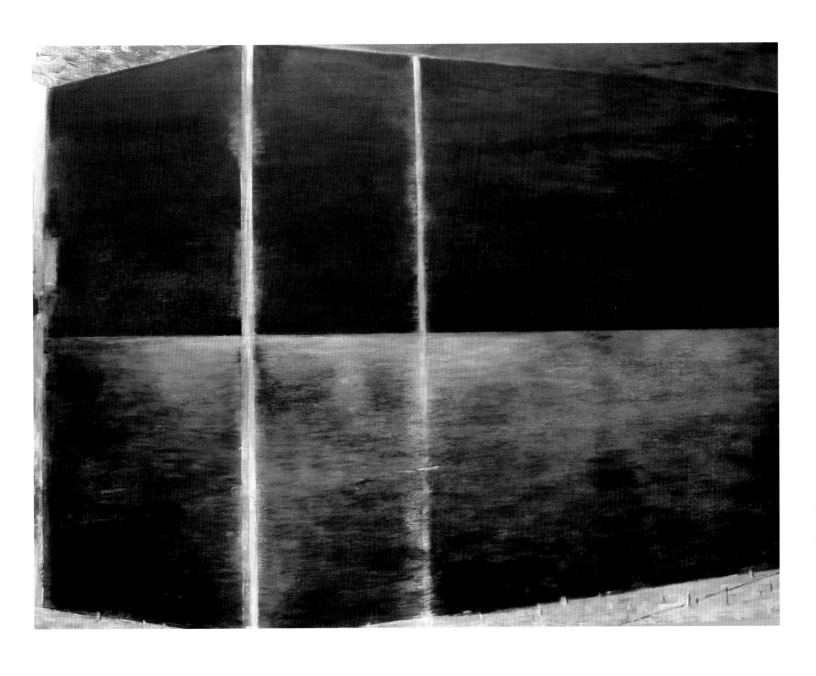

29
Night Sailing, 1997, acrylic on canvas, 72 × 96 inches.
Collection of Greenwich Management, Houston.

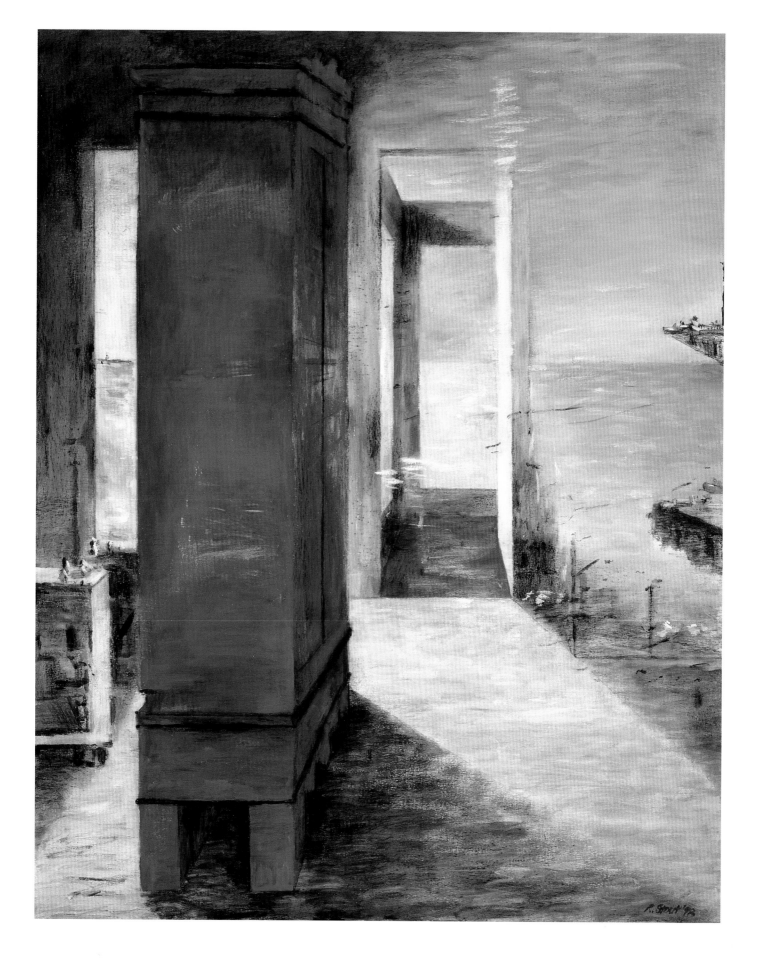

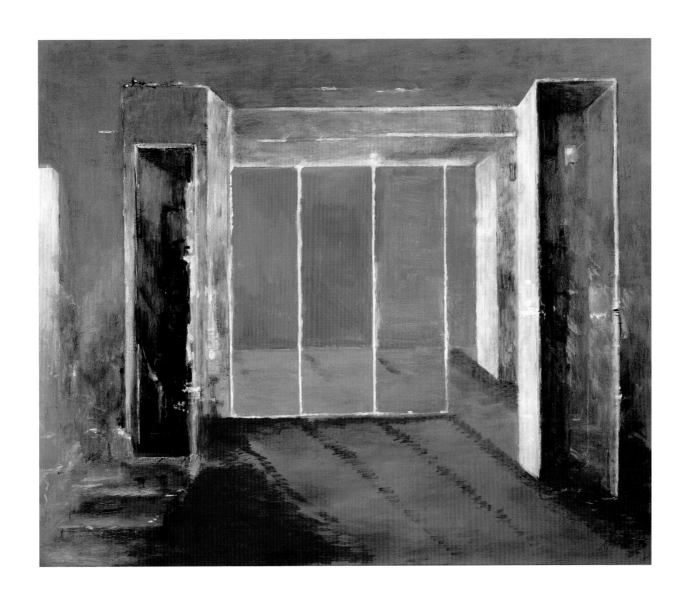

30
(left) *Winter Light*, 1998, acrylic on canvas, 50 × 40 inches.
Courtesy of the artist.

31
(above) *Sound*, 1999, acrylic on canvas, 50 × 60 inches.
Collection by Stephanie Larsen, Houston.

32
The Sweetest Room in the House, 1991, acrylic on canvas,
18 × 24 inches. Collection of Stan Price and Clay Huffard,
Houston.

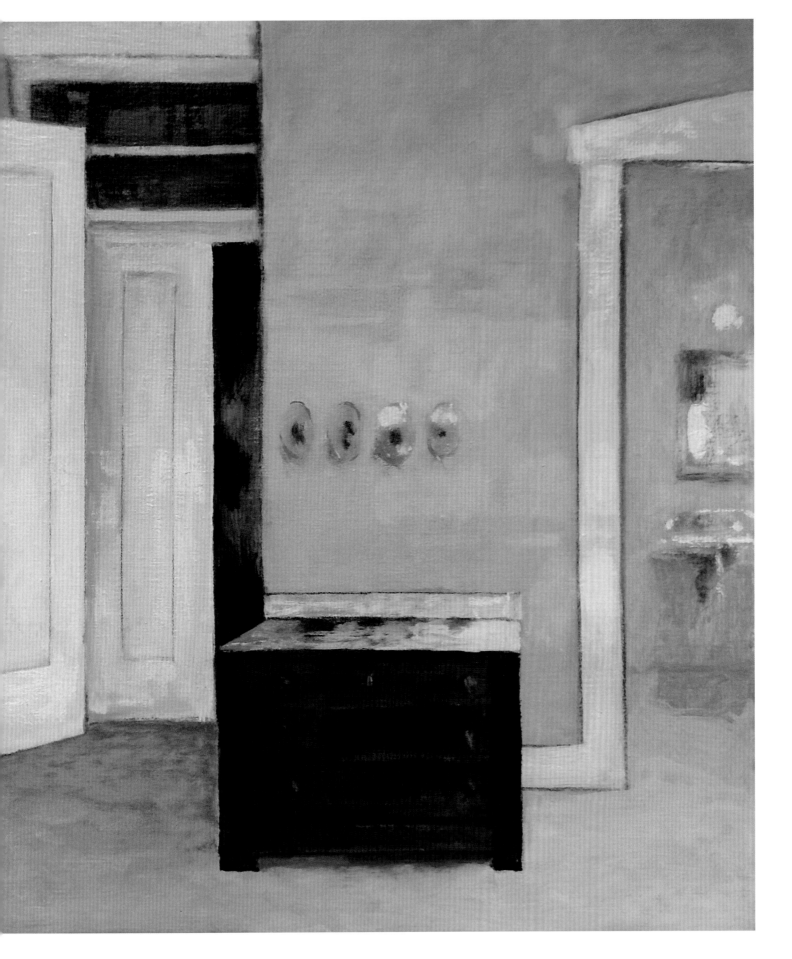

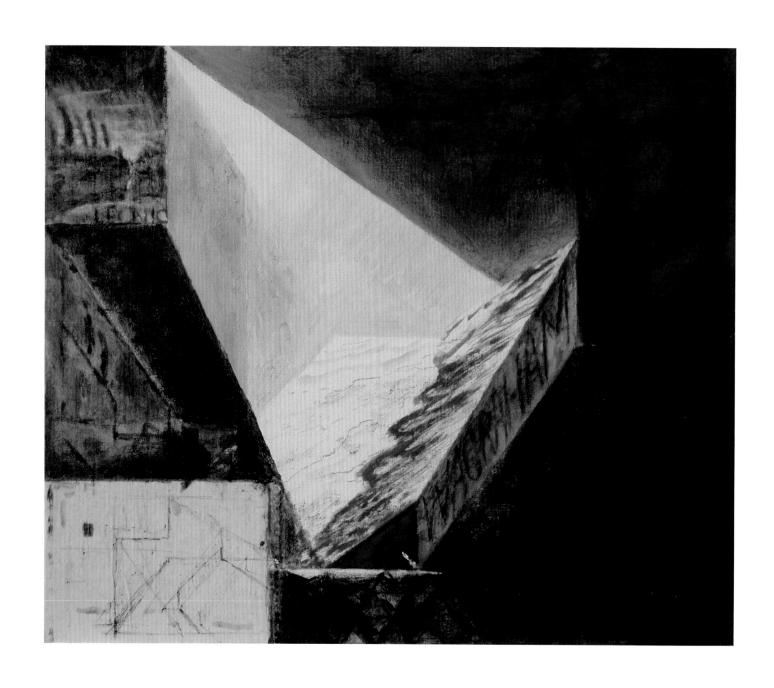

33
(above) *Ron*, 1992, acrylic on canvas, 22 × 26 inches.
Collection of Jody Blazek, Houston.

34
(right) *To Thebes*, 1995, acrylic on canvas, 95 × 66 inches.
Collection of Diane Baker and Edward Stanton, Houston.

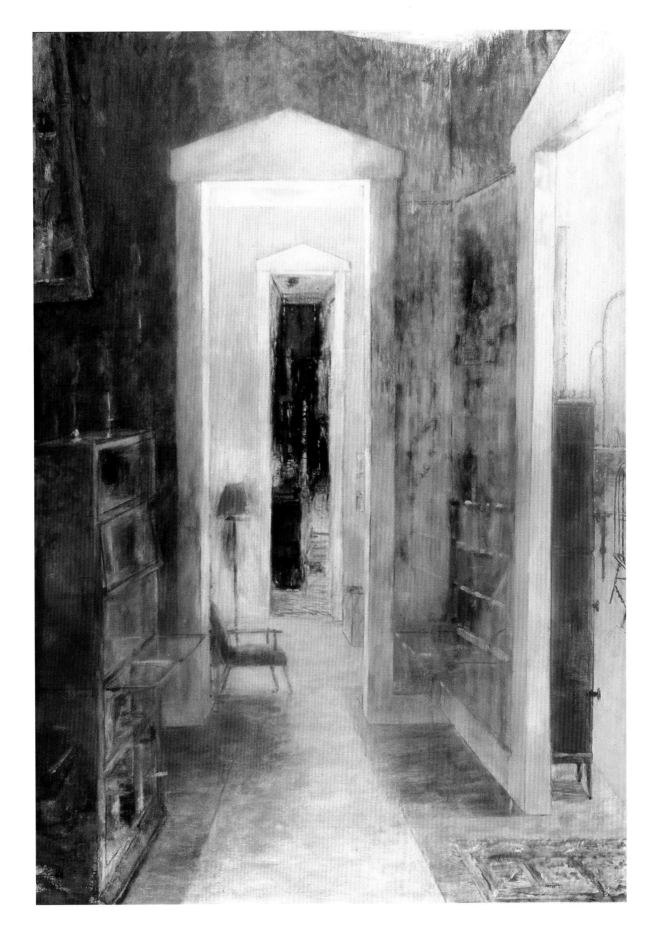

83

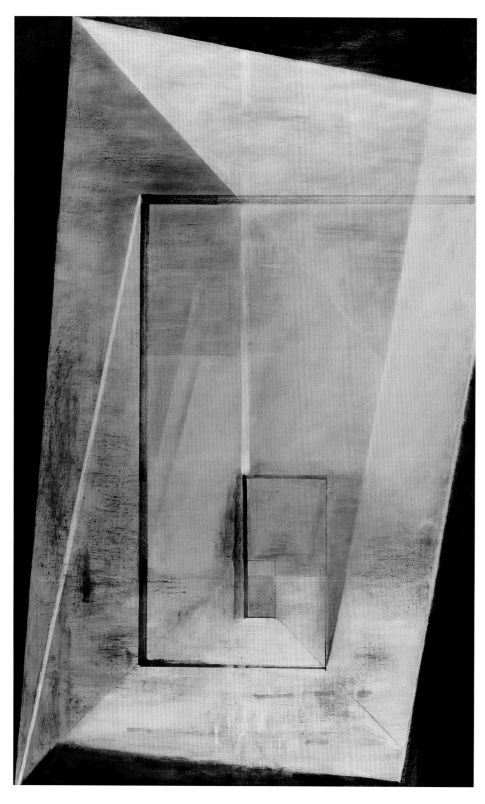

35
On Course, 2015, acrylic on canvas,
32 × 40 inches. Collection of
Mrs. Ardon B. Judd, Houston.

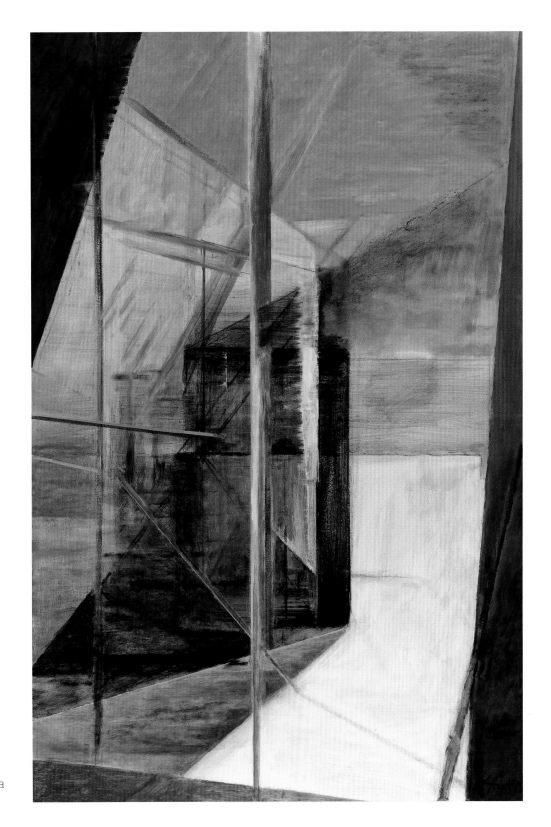

36
Echo, 2015, acrylic on canvas,
60 × 40 inches. Collection of Juka
and Jan Smits, Houston.

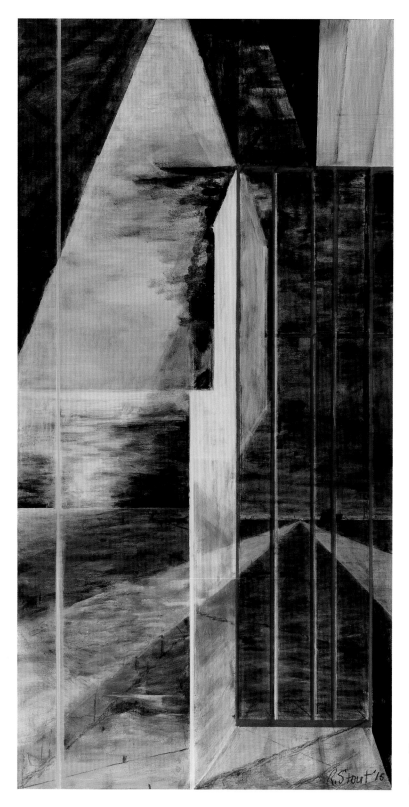

37
The Night Light, 2015, acrylic on canvas, 60 × 30 inches.
Collection of Penn and Margarida Williamson, Houston.

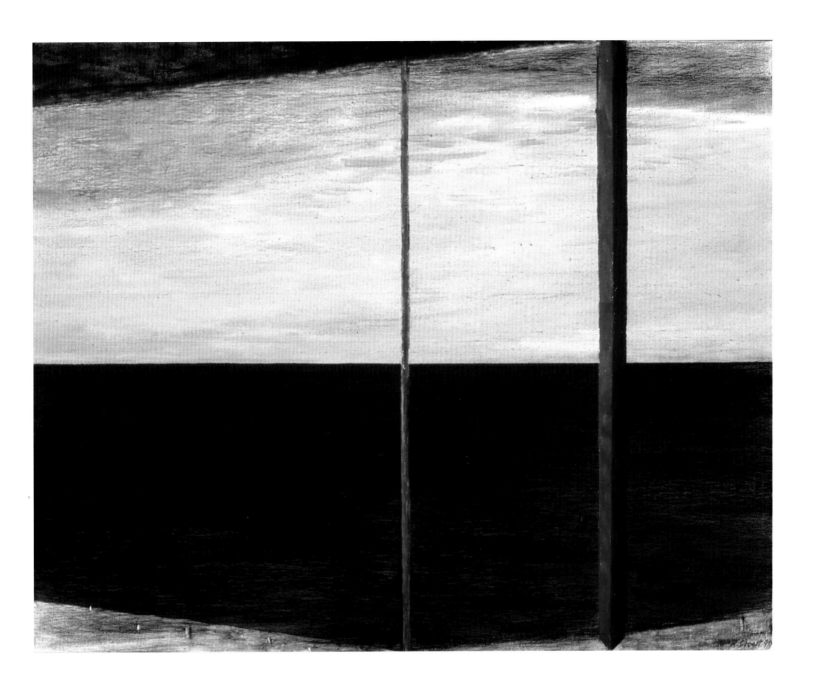

38
From a High Place, 1998, acrylic on canvas, 40 × 50 inches.
Collection of Nancy Manderson, Houston.

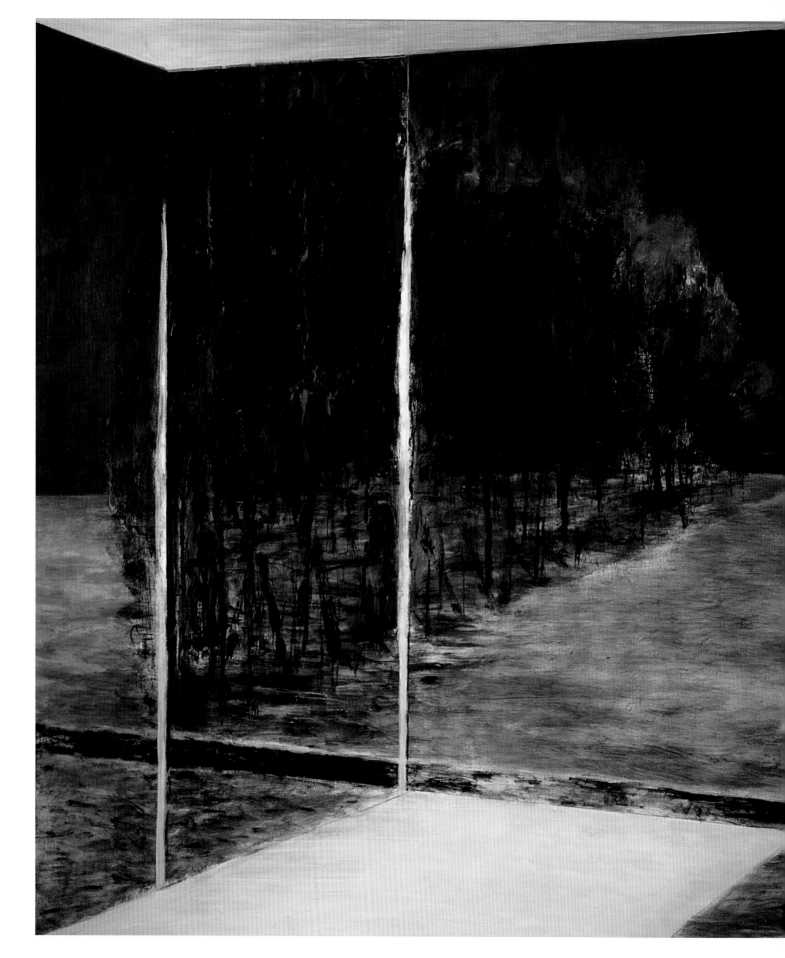

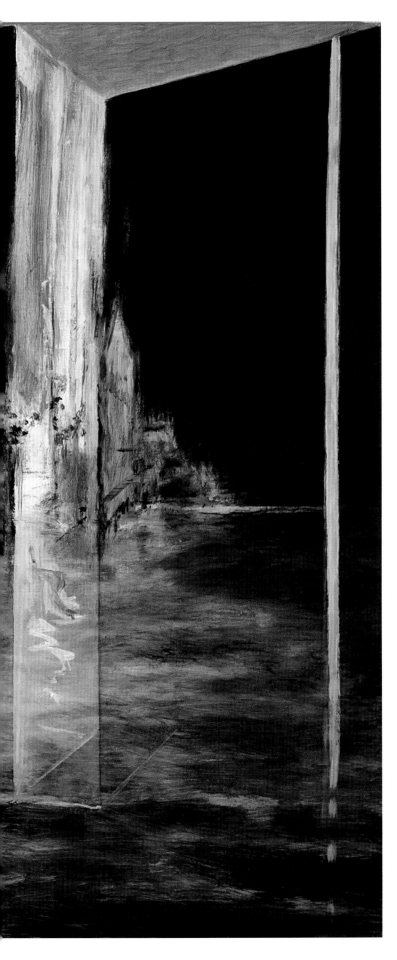

39
Hidden Voyage, 2000, acrylic on canvas, 72 × 96 inches.
Collection of David and Marianne Duthu, Taylor Lake
Village, Texas.

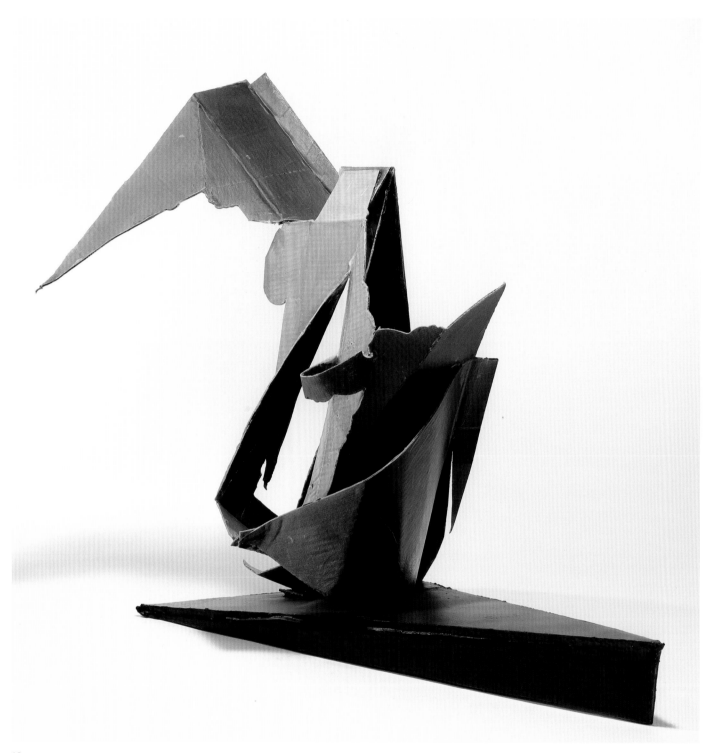

40
Hunter, 2014, mixed media assemblage, 17 × 9 × 22 inches.
Collection of Richard Stout, Houston.

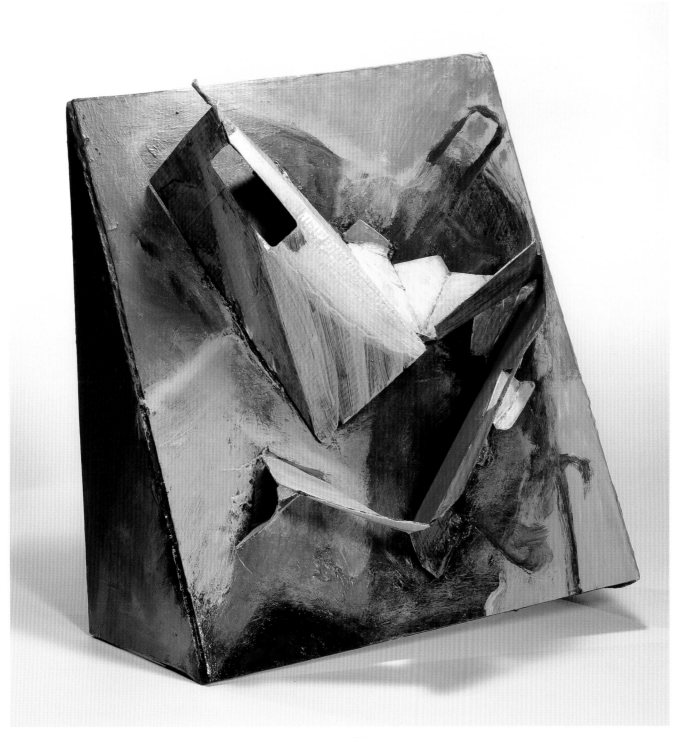

41
Lift Off, 2014, mixed media assemblage, 20 × 17 × 7 inches.
Collection of Richard Stout, Houston.

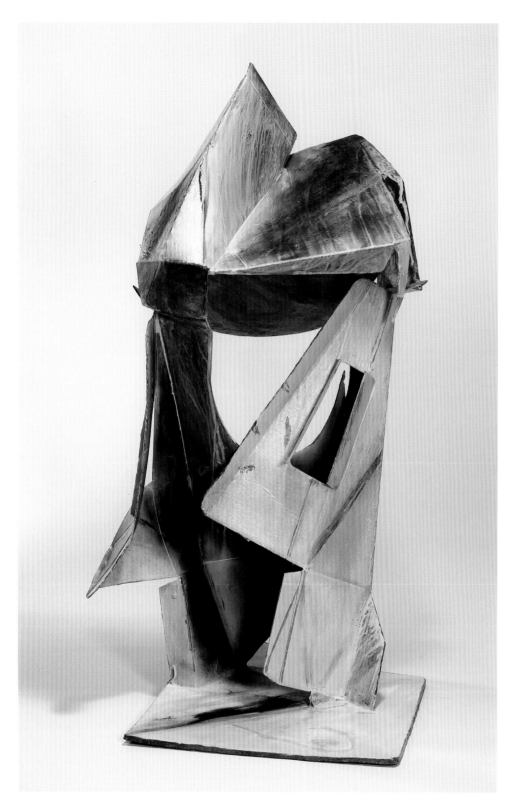

42
Answer Me, 2015, mixed media
assemblage, 25 × 16 × 16 inches.
Collection of Richard Stout, Houston.

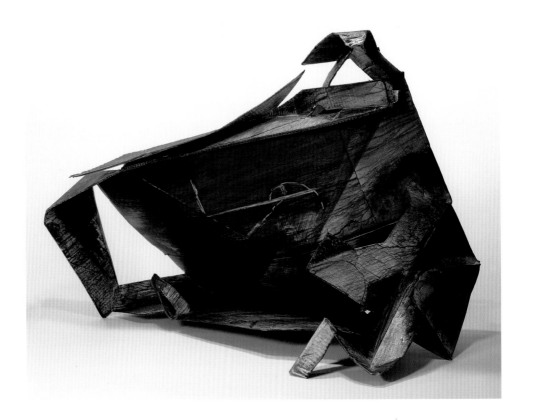

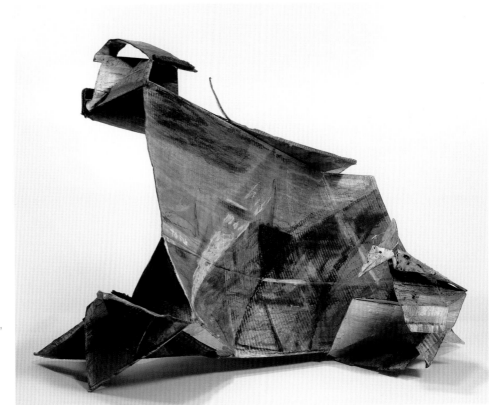

43
To Fly, 2015, mixed media assemblage, 23 × 26 × 30 inches. Collection of Richard Stout, Houston.

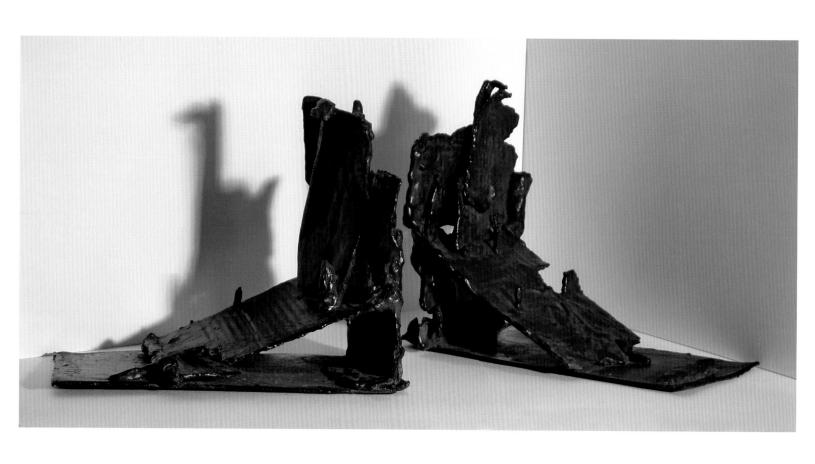

44
Hellespont, 1999, bronze, 11 x 27.5 x 9 inches.
Collection of Richard Stout, Houston.

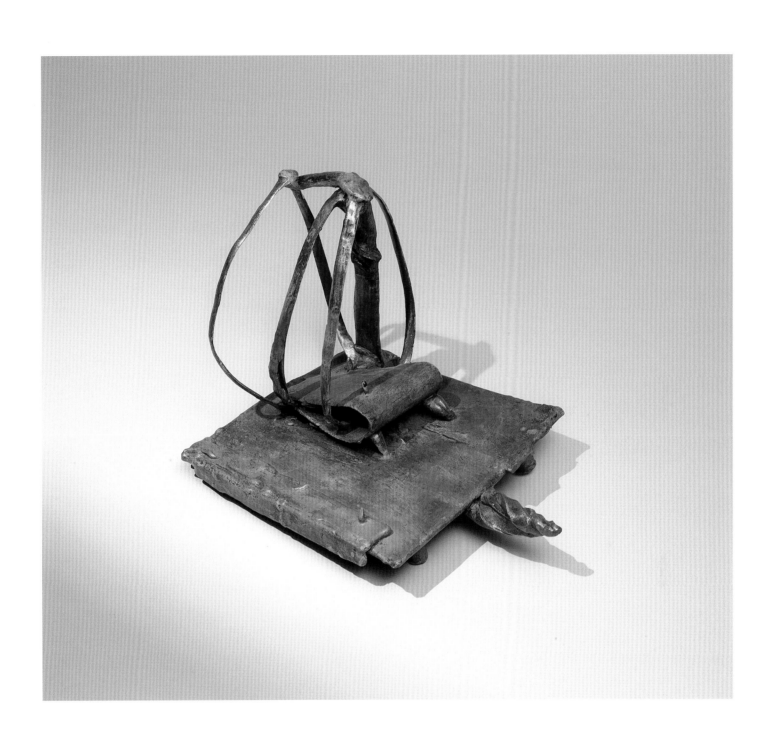

45
To Cythera, 1999, bronze, 8 × 11.5 × 7.5 inches.
Collection of Richard Stout, Houston.

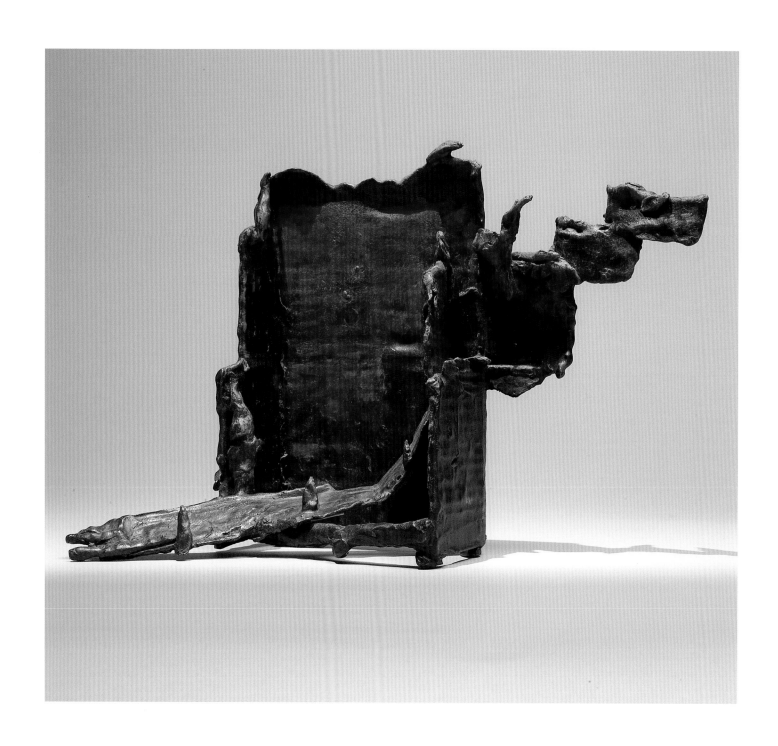

46
The Library at Alexandria, 1999, bronze, 11 × 17.5 × 6 inches.
Collection of Richard Stout, Houston.

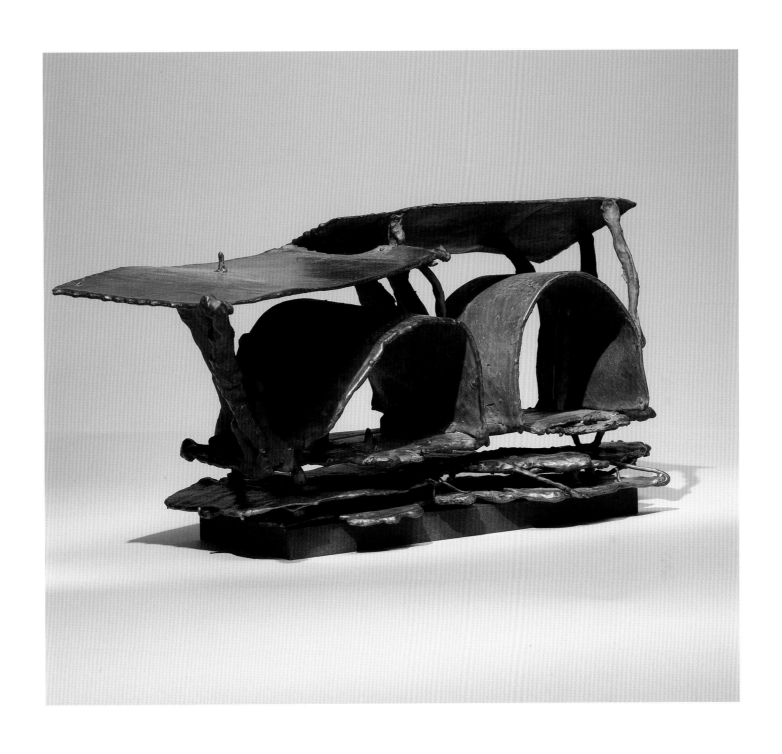

47
Knossos, 1999, bronze, 9.75 × 11 × 6.75 inches.
Collection of Richard Stout, Houston.

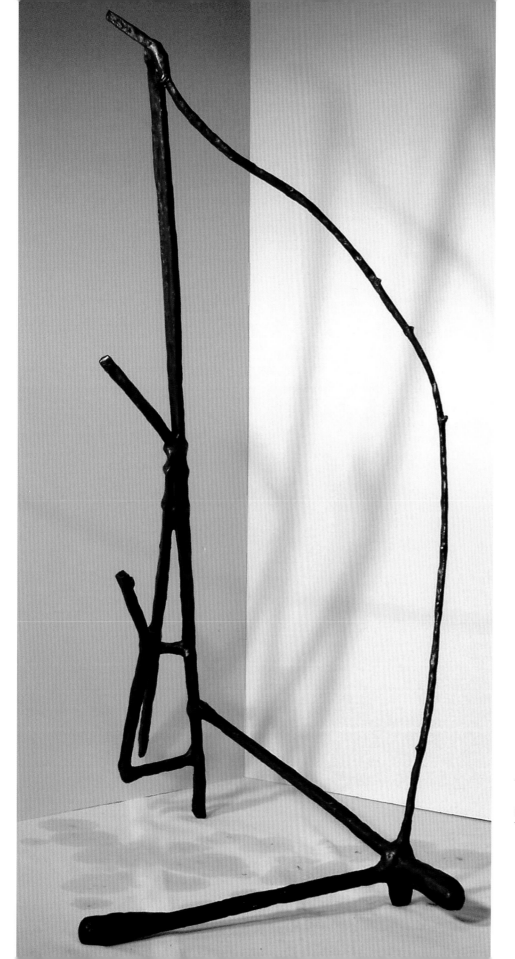

48
Voyage, 2002, bronze, 32.5 × 23 × 15 inches. Collection of Glenn Thomas Turner, Houston.

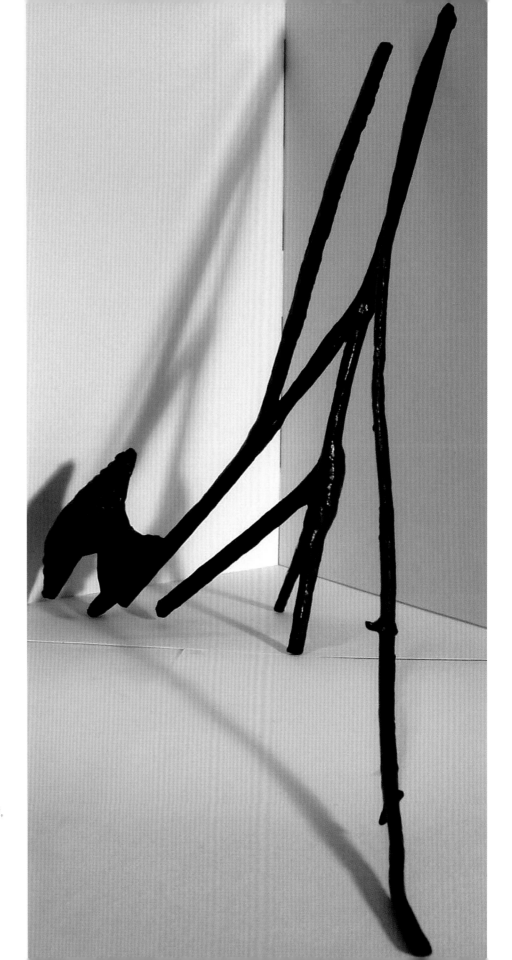

49
Homecoming, 2002, bronze, 23 × 33.5
× 14 inches. Collection of Richard Stout,
Houston.

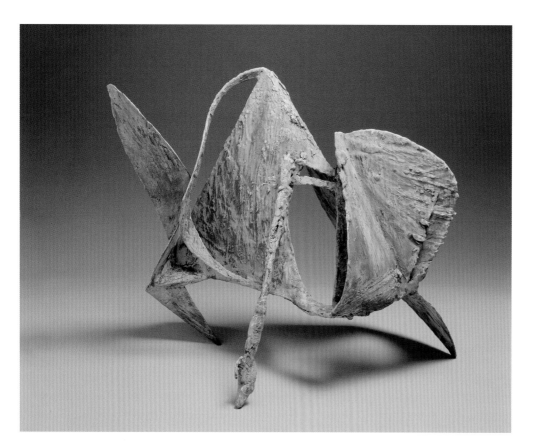

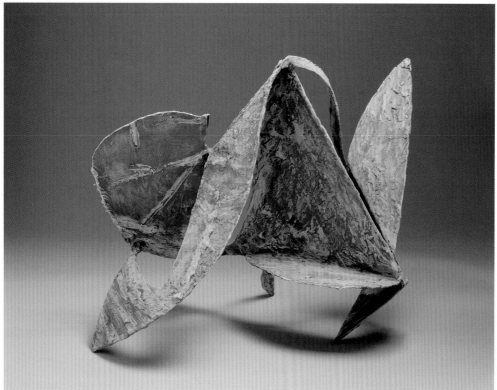

50
Hero, 2005, bronze, 19 × 24 × 15
inches. Collection of Kathleen and
George DeMartino, Dallas.

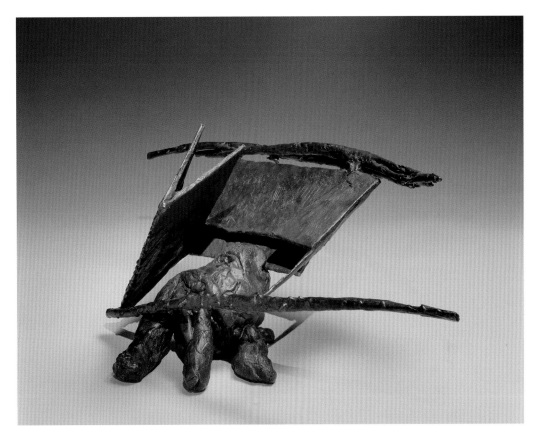

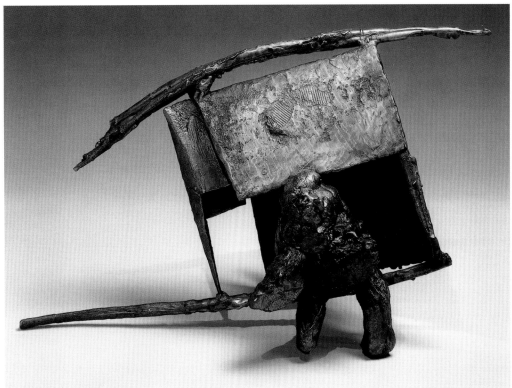

51
Atlas, 2004, bronze, 14 × 21 ×
10 inches. Collection of Richard
Stout, Houston.

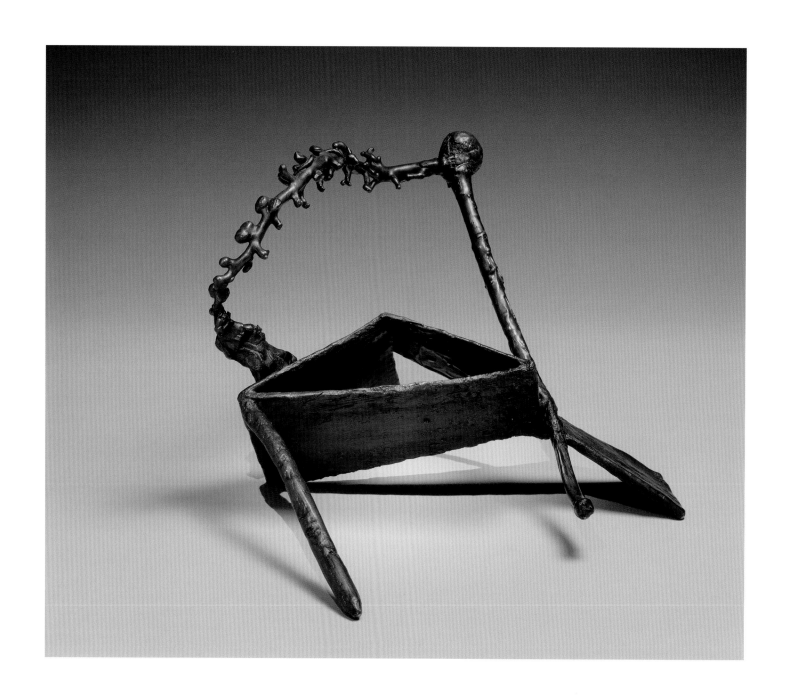

52
Galatea, 2004, bronze, 11 × 16 × 12 inches.
Collection of Richard Stout, Houston.

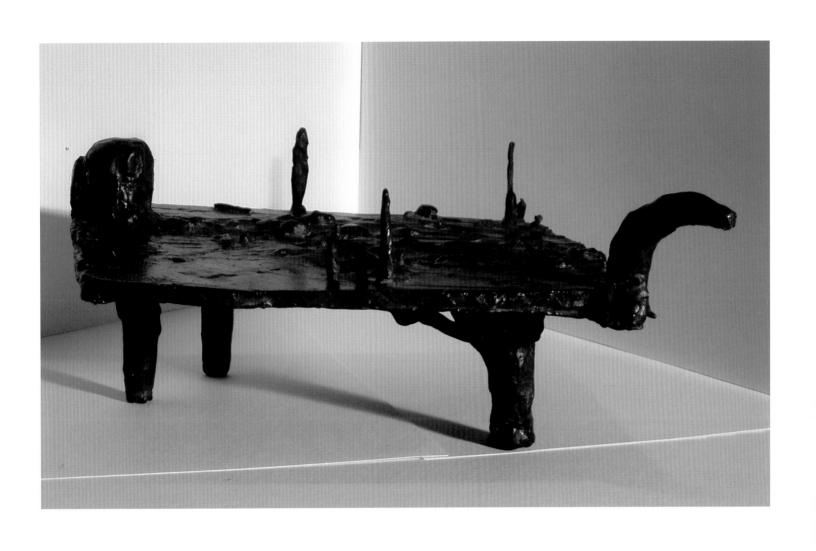

53
Opus I, 1999, bronze, 7.5 × 15 × 16 inches.
Collection of Rick and Nancy Rome, Dallas.

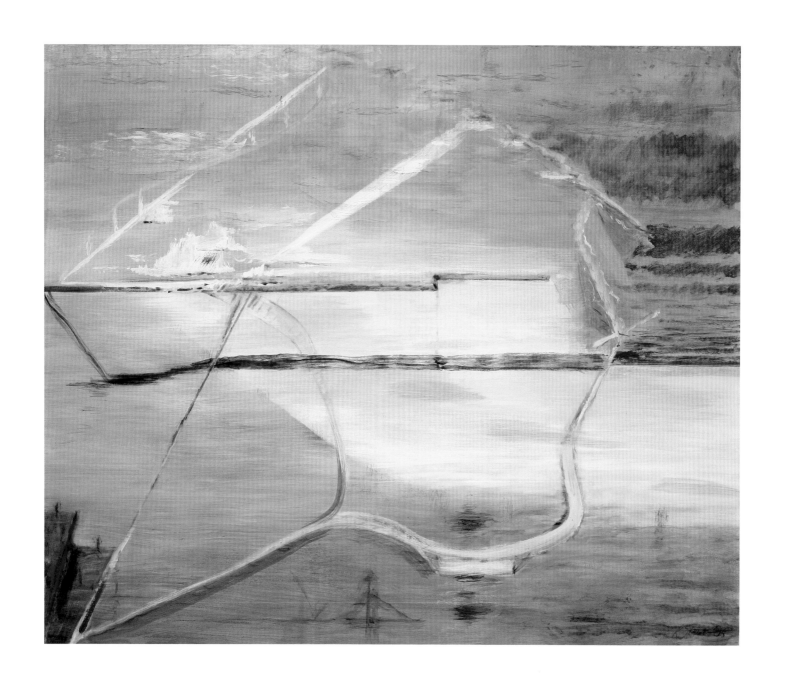

54
Morning, 2005, acrylic on canvas, 50 × 60 inches.
Collection of Richard Stout, Houston.

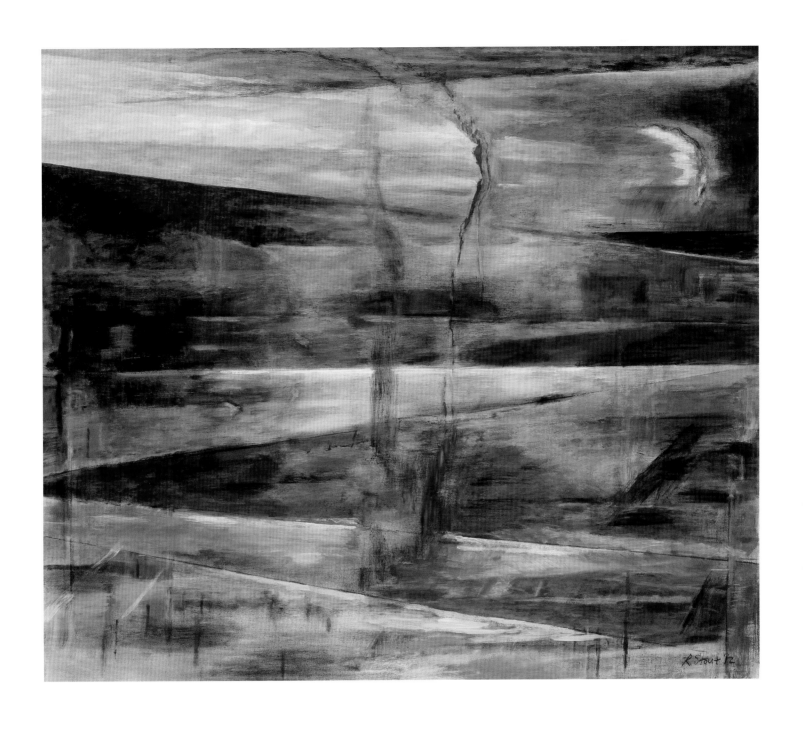

55
Headlands, 2012, acrylic on canvas, 60 × 70 inches.
Courtesy of the artist.

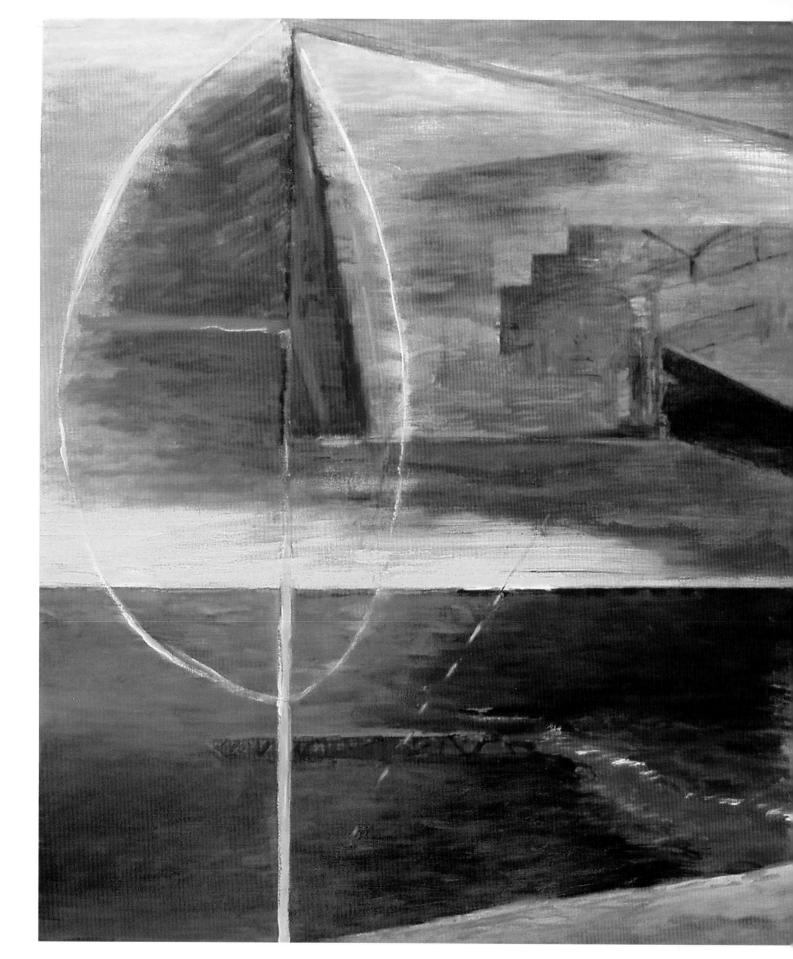

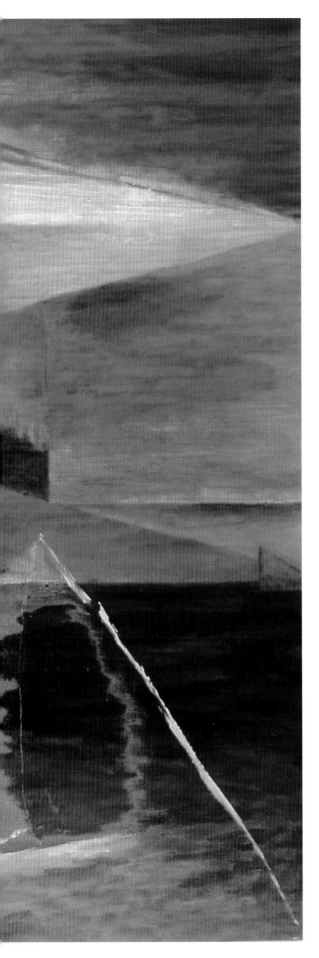

56
Night Fishing, 2004, acrylic on canvas, 48 × 60 inches.
Collection of Barry and Judy Rose, Boise, Idaho.

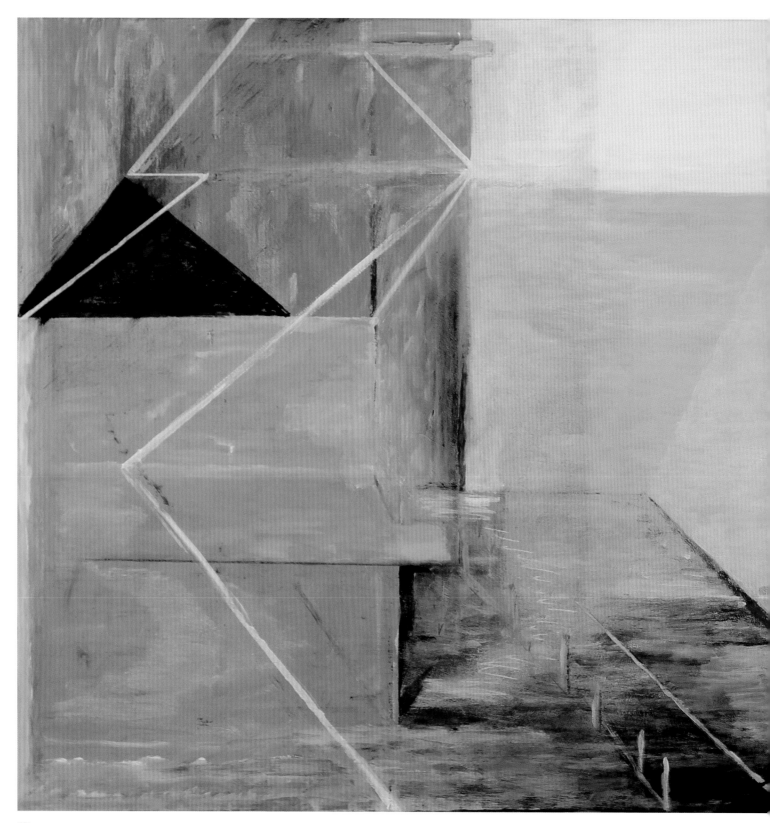

57
A Day at Rollover Bay, 2015, acrylic on canvas,
30 × 60 inches. Collection of Richard Stout, Houston.

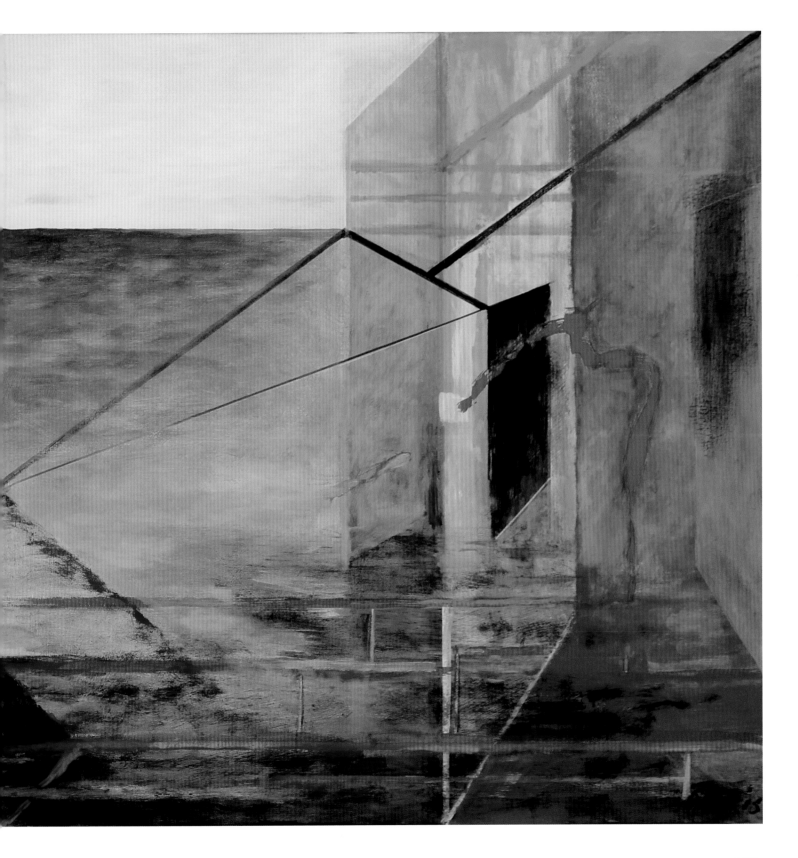

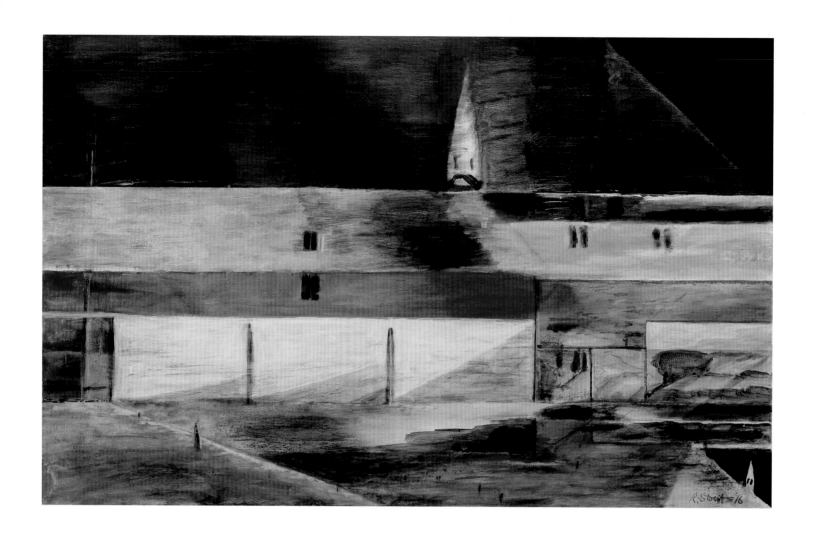

58
(above) *The Way*, 2016, acrylic on canvas, 30 × 48 inches.
Collection of Richard Stout, Houston.

59
(right) *When I Was Young*, 1991, acrylic on canvas, 60 × 50
inches. Collection of Richard Stout, Houston.

110

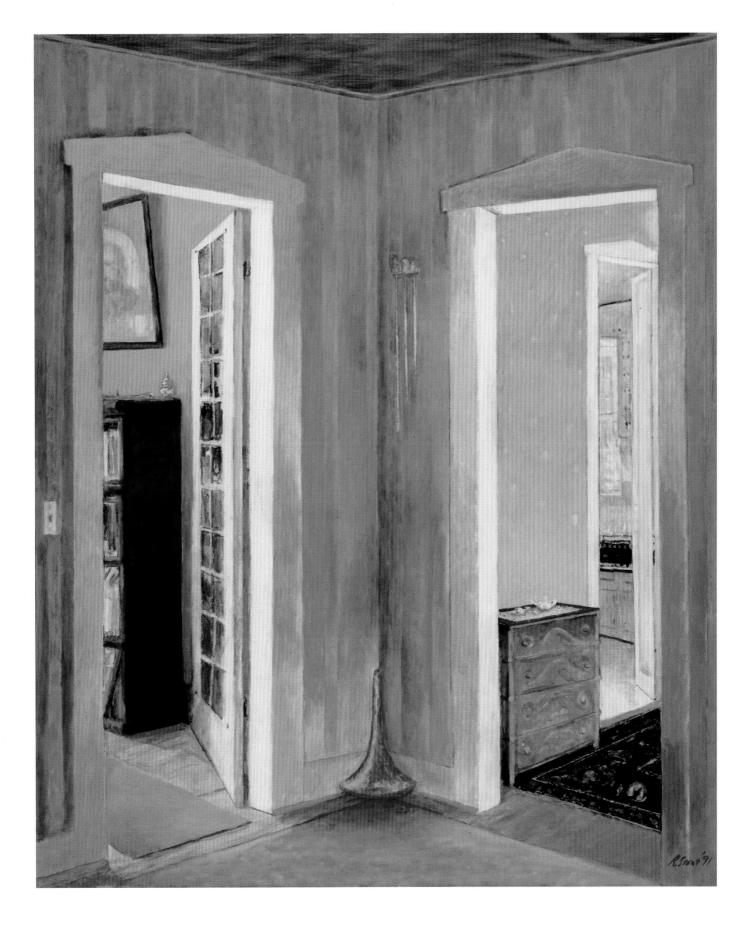

60
To Robert Duncan, 1960, oil on canvas, 46¼ × 64¾ inches.
Collection of Fred Jones Jr. Museum of Art, the University of
Oklahoma Norman; Acquisition.

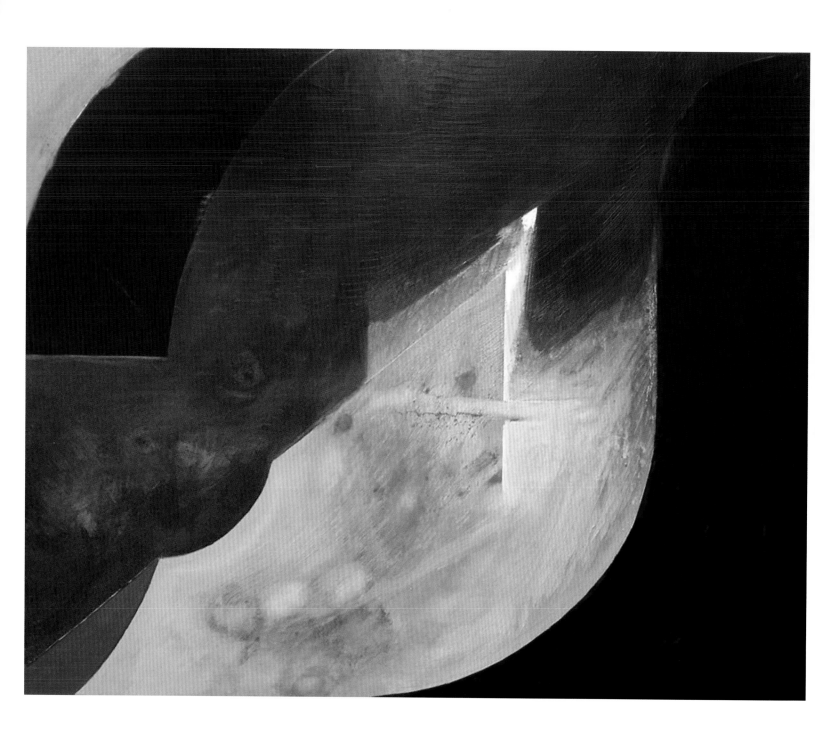

61
For Heroes, 1975, acrylic on canvas, 80 × 100 inches.
Collection of Richard Stout, Houston.

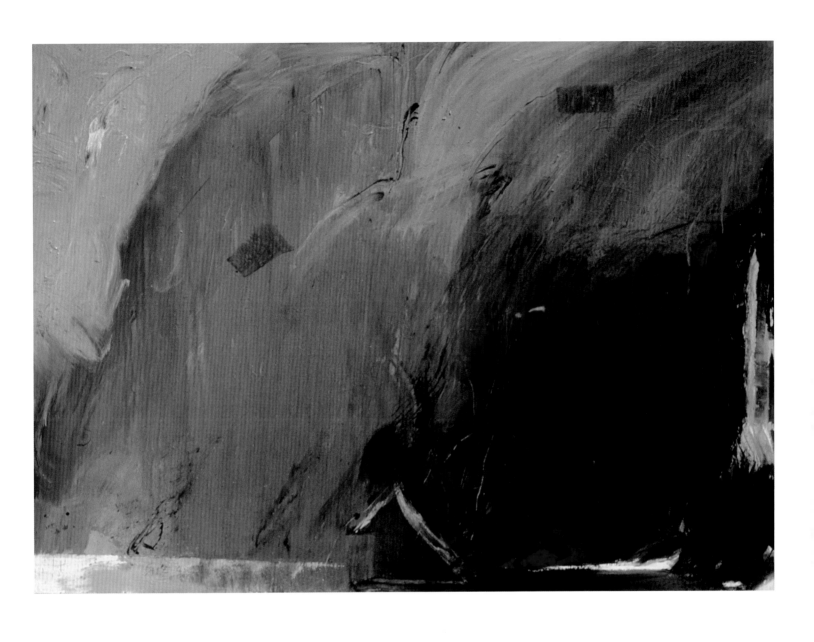

62
Rose City, 1977, acrylic on canvas, 75 × 100 × 2½ inches.
The Museum of Fine Arts, Houston, Gift of Toni and Jeffery
Beauchamp, 2008.245 © Richard Stout.

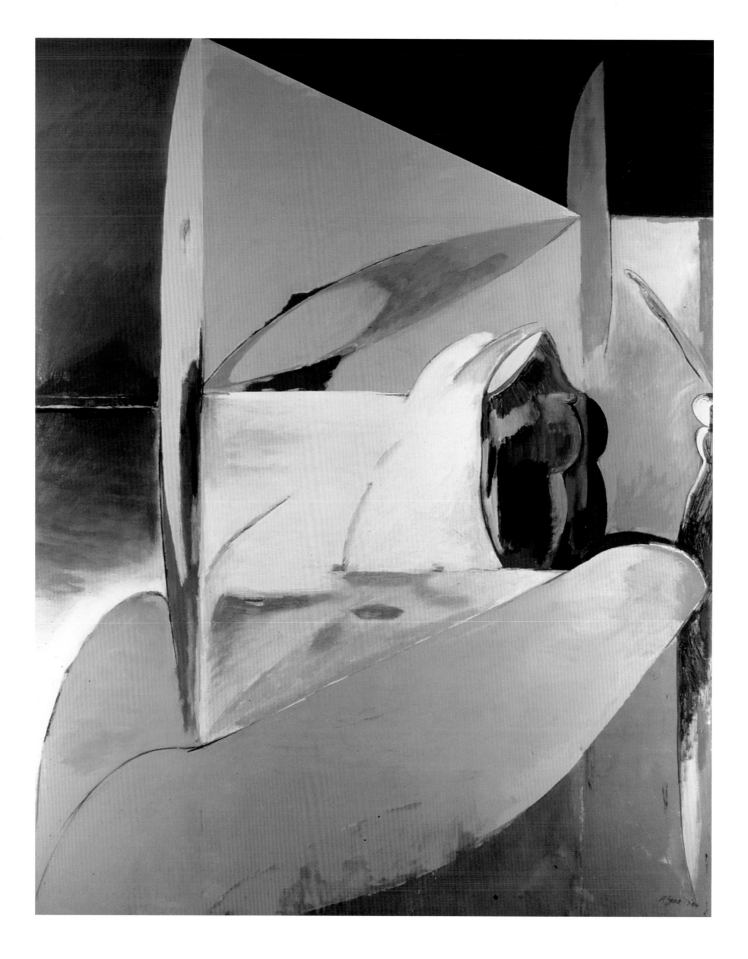

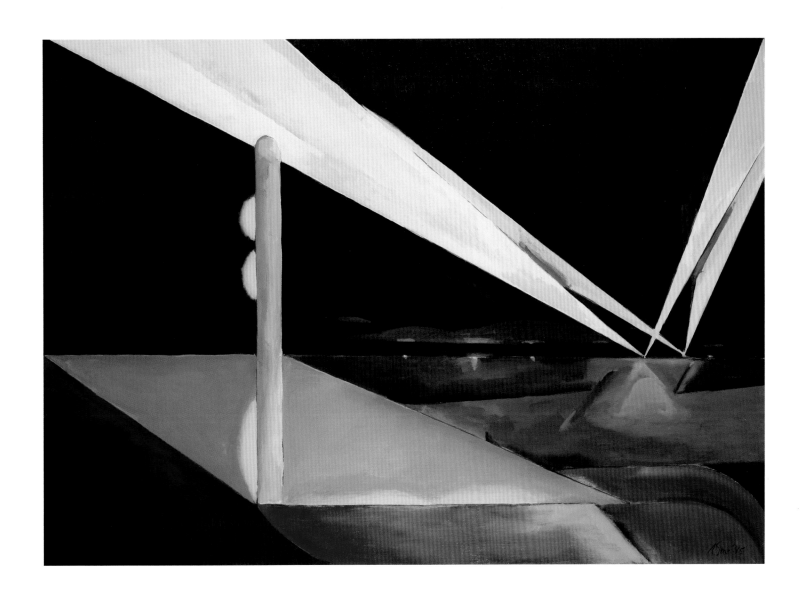

63
(left) *Oedipus*, 1973/1984, acrylic on canvas, 100 × 80 inches.
The Museum of Fine Arts, Houston, Museum purchase funded
by Duke Energy, 85.10 © Richard Stout.

64
(above) *Bolivar Roads*, 1985, acrylic on canvas, 50 × 72
inches. Collection of Joe and April Gauss, Houston.

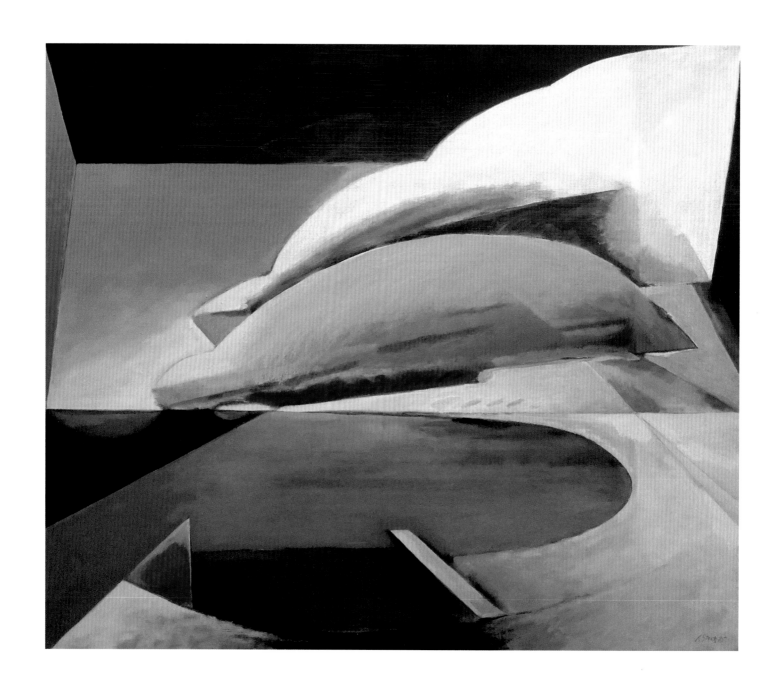

65
(above) *Waiting for God*, 1985, acrylic on canvas, 50 × 60 inches. Collection of Sarah Foltz and Ben Black, Houston.

66
(right) *Ancestors in Charcoal*, 1990, oil on canvas, 65 × 50 inches. Courtesy of the artist.

118

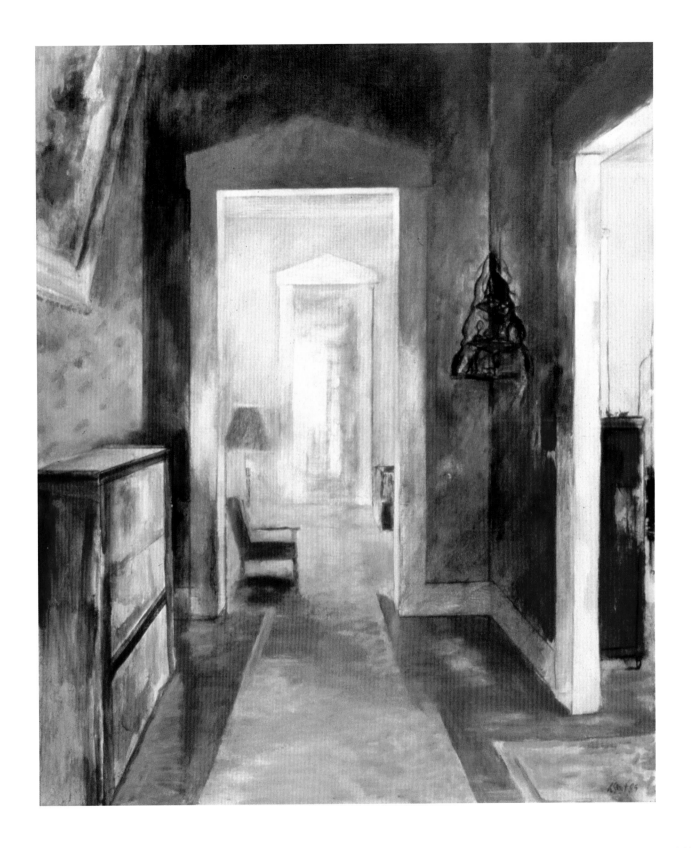

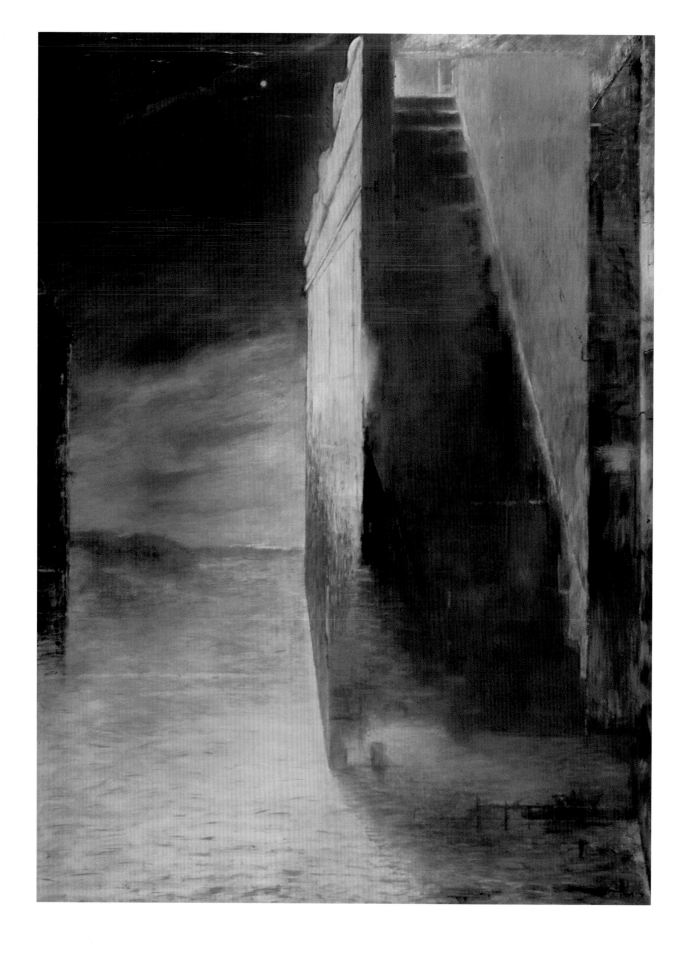

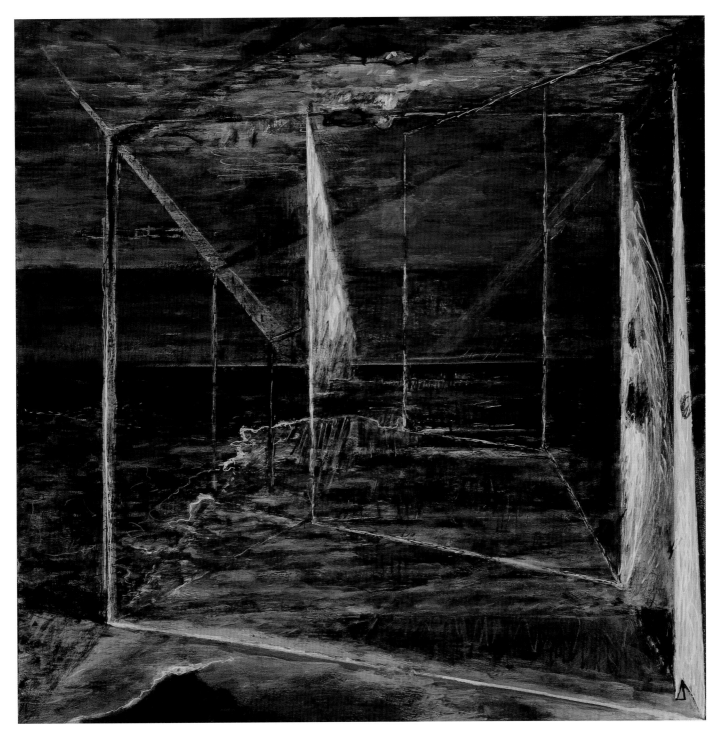

67
(left) *Gibraltar*, 1995, acrylic on canvas, 100 × 75 inches.
Collection of Penn and Margarida Williamson, Houston.

68
(above) *Midnight Fishing*, 2014, acrylic on canvas, 30 × 30
inches. Collection of Karen and Neal Epstein, Houston.

121

ARTIST BIOGRAPHY

Linda J. Reaves

Richard Gordon Stout

Richard Stout was born in 1934 in Beaumont, Texas. He quickly discovered his interest in art and, while still in high school, studied at the Art Academy of Cincinnati during summer visits with family in Ohio. Stout received a scholarship to attend the School of Art at the Art Institute of Chicago, where he earned his bachelor of fine arts (BFA). He completed graduate studies and earned his master of fine arts (MFA) at the University of Texas at Austin. From 1959 to 1967, Stout was an instructor at the Museum School of the Museum of Fine Arts, Houston. After completing his MFA, he began teaching art at the University of Houston, a career he maintained until his retirement in 1996. Stout was named Texas Artist of the Year in 2004 by the Art League of Houston and, in 2010, received the Lifetime Achievement Award from the Center for the Advancement and Study of Early Texas Art (CASETA). He resides in Houston, Texas.

Selected Prizes, Awards

Purchase Prize, Beaumont Art Museum Tri-State Annual Exhibit, 1956

Cash Award, Houston Annual, 1958

Purchase Prize, Texas General, 1962

First Prize, Houston Area Exhibition, 1975

Selected Solo Exhibitions

1958, 1961 Beaumont Art Museum, Beaumont

1959 New Arts Gallery, Houston

1959 Hayden Calhoun Galleries, Dallas

1964 Kansas City Art Institute, Kansas City, Missouri

1968 Yaddo, Saratoga Springs, New York

1968, 1971 McNay Art Institute, San Antonio

1973 Tyler Museum of Art, Tyler (catalogue)

1975 *Richard Stout: Recent Paintings*, Contemporary Arts Museum, Houston

1981 Jurgen Schweinebraden, East Berlin, East Germany

1983 Touchstone Gallery, New York City

1984 M.S.C. Gallery, Texas A&M University, College Station

1987–1989, 1991 W. A. Graham Gallery, Houston

1994 *Richard Stout's Paintings*, Davis-McClain Gallery, Houston (catalogue)

1996 Barbara Davis Gallery, Houston

1997 Texas A&M University, College Station

1997 *Structures of Intimacy*, Artist's home, Houston (catalogue)

1997 *Paintings & Drawings*, Museum of East Texas, Lufkin

1998 Galveston Art Center, Galveston

1998 *Richard Stout Paints*, Mario Villa Gallery, New Orleans

1998 Mulcahy Modern, Dallas

1999 *Soul's Journey*, Art Museum of Southeast Texas, Beaumont; Brevard County Museum of Art and Science, Melbourne, Florida (catalogue)

1999 *The Vernacular of Beauty*, Artist's home, Houston (catalogue)

2000 *Richard Stout*, Art Museum of Melbourne, Florida

2001 *In Pursuit of the Sublime*, Pillsbury and Peters Fine Art, Dallas (catalogue)

2003 *Recent Work*, Pillsbury and Peters Fine Art, Dallas

2004 *Approaching the Limits of Space*, Artist's home, Houston (catalogue)

2004 *Texas Artist of the Year 2004*, Art League of Houston

2004 *Richard Stout: 2004 Texas Artist of the Year*, Chase Bank Heritage Hall, Houston

2004 *New Photogravures*, Tembo Collaborative Studio, Houston

2006 *Recent Paintings, Sculpture, Photogravures*, Holly Johnson Gallery, Dallas; Houston

2006 *The Arc of Perception*, Artist's home, Houston (catalogue)

2009 *Gulf Coast Communion: 35 Impressions of the Texas Coast 1950–2009*, William Reaves Fine Art, Houston (catalogue)

2010 *Alternate Realities*, Beeville Art Museum, Beeville, Texas (catalogue)

2010 *Richard Stout Paintings—Sky, Sea & Earth*, UAC Gallery, Houston Baptist University, Houston (catalogue)

2011 *Painting and Sculpture from 2010 and 2011*, Artist's home, Houston

2011 *The Early Years*, William Reaves Fine Art, Houston

2013 *The Last Home Show*, Artist's home, Houston

2015 *Return to the Sea*, William Reaves Fine Art, Houston

Selected Group Exhibitions
1950–1959

Beaumont Art League, Beaumont (1951–1952)

Cincinnati Art Academy, Cincinnati (1952–1953)

School of the Art Institute of Chicago (1953–1957)

Tri-State Annual, Beaumont Art Museum, Beaumont (regular exhibitions, 1955–1978, purchase prize, 1956)

The 1014 Art Center, with Jack Beal, Chicago (1956)

Chicago and Vicinity Exhibition, Art Institute of Chicago (1957)

Denver Museum of Art Annual Exhibition, Denver (1957)

Momentum, Mid-Continental Exhibition, Chicago (1957, catalogue)

Wells Street Gallery, Chicago (1957–1958)

Cushman Gallery, Houston (1957–1958)

Texas Oil '58, A Salute to the Oil Industry of the State by Texas Painters, Museum of Fine Arts, Houston, circulated: Bank of the Southwest, Houston; Dallas Public Library, Dallas; Republic National Bank of Dallas (1958, catalogue)

33rd Annual Houston Artists Exhibition, Museum of Fine Arts, Houston (December 1958, cash award)

Museum School, Museum of Fine Arts, Houston (1958–1959)

New Arts Gallery, Houston (1958–1960)

34th Annual Houston Artists Exhibition, Museum of Fine Arts, Houston (1959)

D. D. Feldman Competitive Award Exhibit: The Contemporary Work of 82 Texas Artists, traveling exhibition (1959)

Made in Texas by Texans, Dallas Museum of Contemporary Art, Sheraton-Dallas Hotel, Dallas (1959, catalogue)

1960–1969

Delgado Museum of Art, Annual Exhibition, New Orleans (1960)

35th Annual Houston Artists Exhibition, Museum of Fine Arts, Houston (1960)

Butler Institute of American Art, Annual Exhibition, Youngstown, Ohio (1960)

American Provincetown Exhibition, Provincetown, Massachusetts (1960)

Fifth International Hallmark Art Award Exhibition, Wildenstein Gallery, New York City; Museum of Fine Arts, Houston (1960–1961)

Sun Carnival Annual Exhibition, El Paso Museum of Art, El Paso (1960–1970)

Contemporary Arts Museum, Houston (1961)

Second Triennial of Original Watercolor Graphics, Basel, Switzerland (1961)

Oklahoma Annual Exhibition, Oklahoma City (1961–1970)

24th Annual Texas Painting and Sculpture Exhibition 1962–1963, circulated: Witte Museum, San Antonio; Centennial Art Museum, Corpus Christi; Beaumont Art Museum, Beaumont; Dallas Museum of Art, Dallas (1962, purchase prize by Dallas Museum of Art)

Museum School Faculty Exhibition, Museum of Fine Arts, Houston (1962–1963)

Meredith Long & Company, Houston (1962–1986, solo and group exhibitions)

13th Southwestern Exhibition of Prints and Drawings, Dallas Museum of Art, Dallas (1963)

25th Annual Texas Painting and Sculpture Exhibition 1963–1964, circulated: Dallas Museum of Art, Dallas; Centennial Art Museum, Corpus Christi; Beaumont Art Museum, Beaumont; El Paso Museum of Art, El Paso; Witte Museum, San Antonio; University of Texas at Austin (1963)

Houston Dimension Exhibition, Houston (1964)

Festival of the Bible in the Arts, Temple Emanuel, Houston (1964)

Texas Painting & Sculpture Annual, Dallas Museum of Art, Dallas (1965)

100 Contemporary American Drawings (collection of Museum of Fine Arts, Houston), Museum of the University of Michigan, Ann Arbor (1966)

Faculty Exhibition, University of Houston (regularly 1967–1980)

The Sphere of Art in Texas, Texas Fine Arts Commission, Texas Pavilion, Hemisfair '68, San Antonio (1968)

Contemporary American Art, US Department of Commerce, toured Australia (1968–1970)

1970–1979

Award Winners Exhibition, Museum of Oklahoma, Oklahoma City (1970)

The Larger Canvas, Republic Bank, Houston (1970, catalogue)

The Highway, Rice University, Institute for the Arts, Houston (1970, catalogue)

Texas Fine Arts Association, Austin (1970–1971)

Other Coast Exhibition '71, California State University, Long Beach (1971, catalogue)

Larger Canvas Two, Republic Bank, Houston (1971, catalogue)

Main Street One, City of Houston (1971)

New Works of Former Award Winners, Texas Fine Arts Association, Austin, traveling exhibition (1971)

Three Americans, Texas Fine Arts Association, Austin, traveling exhibition (1972)

Houston Area Exhibition, Blaffer Gallery, University of Houston (1973)

Abstract Painting and Sculpture in Houston, Museum of

Fine Arts, Houston (1974)

Davis and Long Gallery, New York City (1974)

Houston Area Exhibition, Blaffer Gallery, University of Houston (1975, catalogue, first prize)

Five Painters, Pollock Galleries, Southern Methodist University, Dallas (1975)

Beaumont Art Museum, Beaumont (1976–1978)

Houston Area Exhibition, Blaffer Gallery, University of Houston (1977)

Texas Twenty, Nave Museum, Victoria, Texas (1977)

Art Today: U.S.A. III, Tehran, Iran (1977)

International Art Fair, Cologne, West Germany (1977)

Doors: Houston Artists, Alley Theatre, Houston Festival, Houston (1979, catalogue)

Achenbach & Kimmerich, Düsseldorf, West Germany (1979)

1980–1989

Man and the Environment, International Graphic Portfolio, fifty invited artists, Jurgen Schweinebraden, East Berlin, East Germany (1980, catalogue)

Eros, Julius Hummel Kunsthandlung, Vienna (1980)

Gallerie Thommen, Basel, Switzerland (1980)

Gallerie de Arti Pellegrino, Bologna, Italy (1981)

Art from Houston in Norway 1982, Stavanger Kunstforening; Tromso Kunstforening; Christiansand Kunstforening; Oslo Kunstforening (1982, catalogue)

Triennial, New Orleans Museum of Art, New Orleans (1983, catalogue)

Southern Fictions, Contemporary Arts Museum, Houston (1983, catalogue)

New Art from a New City: Houston, Salzburger Kunstverein, Salzburg, Austria, circulated: Galerie an der Stadtmauer, Villach, Austria; Museum of Modern Art, Vienna; Frankfurter Kunstverein, Frankfurt, West Germany, and other sites (1983, catalogue)

1984, Contemporary Arts Museum, Houston (1984)

Fresh Paint: The Houston School, Museum of Fine Arts, Houston, circulated: Institute for Art and Urban Resources, Inc. (MoMA PS1), Queens, New York; Oklahoma Contemporary Art Center, Oklahoma City (1985, catalogue)

The Avant Old Guard, 1600 Smith, Houston (1985)

Works on Paper: Eleven Houston Artists, Museum of Fine Arts, Houston (1985, catalogue: same as *New Art from a New City: Houston*, 1983, traveled to Austria and Germany)

25th Anniversary Exhibition, Meredith Long & Company, Houston (1985)

The Texas Landscape, 1900–1986, Museum of Fine Arts, Houston (1986, catalogue)

Houston '88, 1600 Smith, Houston (1988)

McNay Museum of Art, San Antonio (1988)

Drawn from Life, Sewell Art Gallery, Rice University, Houston (1988)

Texas Art: An Exhibition Selected from the Menil Collection, Museum of Fine Arts, Houston and Trustees' Collection of the Contemporary Arts Museum, Menil Collection Richmond Hall, Houston (1988, catalogue, texts by Neil Printz, Marilyn Zeitlin, and Alison de Lima Greene)

Looking at Color, Transco Tower, Houston (1989)

The Food Show, Grand Central Galleries, New York City (1989)

Texas Figurative Art, Art Museum of Southeast Texas, Beaumont (1989)

1990–1999

Texas Art Celebration '91, Assistance League of Houston (1991)

Island Inspired, Galveston Art Center, Galveston (1992)

Conventional Forms/Insidious Visions, Glassell School of Art, Houston (1993)

Texas Art Celebration '93, Assistance League of Houston (1993)

Faith in Vision, Transco Tower Gallery, Houston (1995)

Houston Area Exhibition, Blaffer Gallery, University of Houston (1996)

Texas Modern and Postmodern, Museum of Fine Arts, Houston (1996, catalogue)

2000–2009

Pillsbury & Peters Fine Art, Dallas (2000)

A Selection of Art Made in Houston 1950–1965, Brazos Projects, Brazos Bookstore, Houston (2004)

Inaugural Exhibition, Holly Johnson Gallery, Dallas (2005)

Houston Art in Houston Collections: Works from 1900 to 1965, Heritage Society Museum, Houston (2006)

Jack Boynton and Richard Stout: Early Works in Houston, William Reaves Fine Art, Houston (2007)

Texas Modern: The Rediscovery of Early Texas Abstraction (1935–1965), Martin Museum of Art, Baylor University, Waco (2007, catalogue)

Painting West Texas: 35 Artists/100 Years, William Reaves Fine Art, Houston (2009, catalogue)

A Texas Sampler: Vintage Paintings by Thirty Texas Artists, William Reaves Fine Art, Houston (2009)

Back to the Future: Elements of "Modern" in Mid-Century Texas Art, William Reaves Fine Art, Houston (2009)

Texas Paper: Watercolors, Pastels and Drawings from the Lone Star State, 1938–2008, William Reaves Fine Art, Houston (2009)

Texas Art Seen, Grace Museum, Abilene, Texas (2009–2010)

The Texas Aesthetic: Contemporary Texas Regionalism,

Annual Exhibition, William Reaves Fine Art, Houston (2009–2010)

2010–Present

Water Rites: Rivers, Lakes, and Streams in Texas Art, William Reaves Fine Art, Houston (2010)

Third Anniversary Show: A Tribute to Houston Artists, William Reaves Fine Art, Houston, Texas (2010)

The Presence of Light: Sky and Light in the Texas Landscape, William Reaves Fine Art, Houston (2010)

Texas Collages: A Tribute to Kurt Schwitters, William Reaves Fine Art, Houston (2010)

Southeast Texas Art: Cross-Currents and Influences 1925–1965, Art Museum of Southeast Texas, Beaumont (2011)

Lone Star Modernism: A Celebration of Mid-Century Texas Art, William Reaves Fine Art, Houston (2011)

Portrait of Houston: 1900–2011, Alliance Gallery, Houston Arts Alliance, Houston (2011, catalogue)

Breakthrough: Sixty Years of Texas Abstraction, William Reaves Fine Art, Houston (2011)

A Survey of Texas Modernists, William Reaves Fine Art, Houston (2012)

Texas Expressionism, William Reaves Fine Art, Houston (2012)

Restless Heart: The Collectors' Quest to Find Texas in Art, San Angelo Museum of Fine Arts, San Angelo (2013)

A Tribute to Texas Rivers, William Reaves Fine Art, Houston (2013)

Rhythms of Modernism, William Reaves Fine Art, Houston (2013)

Summer Encore Exhibition, William Reaves Fine Art, Houston (2013)

Lives Played Out on Canvas: Paintings by Otis Huband, Richard Stout and Dick Wray, William Reaves Fine Art, Houston (2013)

Houston Founders at City Hall Art Exhibition, City Hall, Houston (2014)

Pursuit of the Sublime: *The Art of David Cargill & Richard Stout*, William Reaves Fine Art, Houston (2014)

A New Visual Vocabulary: *Developments in Texas Modernism 1935–1965*, One Allen Center, Lobby Gallery, Houston (2014)

Lone Star Masters of Modernism, William Reaves Fine Art, Houston (2014)

Macrocosm/Microcosm: *Abstract Expressionism and the American Southwest*, Fred Jones Jr. Museum of Art, University of Oklahoma, Norman (2014, catalogue)

Bayou City Chic: *Progressive Streams of Modern Art in Houston*, Art Museum of South Texas, Corpus Christi (2015, catalogue)

Texas Modernists: *The Abstract Impulse*, Grace Museum, Abilene, Texas (2015, catalogue)

Texas Originals: *Six Bayou City Expressionists*, William Reaves | Sarah Foltz Fine Art, Houston (2016)

TARGET TEXAS: *The Meaning of Mixed*, Art Museum of South Texas, Corpus Christi (2016)

This WAS Contemporary Art: *Fine and Decorative Arts in Houston 1945–1965*, Heritage Society Museum, Houston (2016, catalogue)

Transient Views: *The Places of Our Lives*, William Reaves | Sarah Foltz Fine Art, Houston (2017)

Selected Public Collections

Art Museum of Southeast Texas, Beaumont

Butler Institute of American Art, Youngstown, Ohio

Dallas Museum of Art, Dallas

Kupferstichkabinett, Museum of Fine Art, Dresden, Germany

McNay Museum, San Antonio

Menil Collection, Houston

Museum of Fine Arts, Houston

University of Houston

University of Texas at Austin

Welch Foundation, Houston

Selected Bibliography

Dallas Museum of Art. Portal to Texas History. Accessed December 23, 2016. http://texashistory.unt.edu/explore/partners/DMA/browse.

Edwards, Katie Robinson. *Midcentury Modern Art in Texas*. Austin: University of Texas Press, 2014.

Greene, Alison de Lima, Peter C. Marzio, Shannon Halwes, and Kathleen Robinson. *Texas*: *150 Works from the Museum of Fine Arts, Houston*. Houston: Museum of Fine Arts, Houston, 2000.

Johnson, Patricia Covo. *Contemporary Art in Texas*. Roseville East, New South Wales, Australia: Craftsman House, 1995.

Museum of Fine Arts, Houston. Exhibition history online. Accessed December 23, 2016. http://prv.mfah.org/archives/search.asp?par1=1&par2=1&par3=1&par4=1&par5=1&par6=1&par7.

Reynolds, Sarah C. *Houston Reflections*: *Art in the City, 1950s, 60s, and 70s*. Houston: Rice University Press, 2008.

Rose, Barbara, and Susie Kalil. *Fresh Paint*: *The Houston School*. Austin: Texas Monthly Press; Houston: Museum of Fine Arts, Houston, 1985. [exhibition catalogue]

ABOUT THE CONTRIBUTORS

William E. Reaves, PhD, is an educator by profession with a deep and abiding interest in art that began in 1976 with the purchase of his first oil painting. He and his wife, Linda, have been active and engaged collectors of Texas art for more than forty years. Reaves is cofounder and former chairperson of CASETA (Center for the Advancement and Study of Early Texas Art). He wrote *Texas Art and a Wildcatter's Dream* in 1996, and coauthored *Of Texas Rivers and Texas Art* in 2017 (with Andrew Sansom), both published by Texas A&M University Press. He currently serves as principal partner in William Reaves | Sarah Foltz Fine Art, a Houston art gallery focusing on historical, midcentury, and contemporary Texas art.

Katie Robinson Edwards, PhD, is curator of the Umlauf Sculpture Garden and Museum in Austin and author of *Midcentury Modern Art in Texas*, published by University of Texas Press in 2014. In addition to curating exhibitions and writing on Texas art, she has written on Chuck Close, Jackson Pollock, Robert Rauschenberg, Jessica Stockholder, Andrew Wyeth, and Jamie Wyeth. She taught modern and contemporary art at the Allbritton Art Institute at Baylor University for eight years.

David E. Brauer, an art historian and native of Scotland, was educated at the Sir Christopher Wren School and St. Martin's School of Art in London. Brauer enjoyed a three-decade career as instructor of art history at the Glassell School (previously the Museum School) of the Museum of Fine Arts, Houston, during which time he also taught simultaneously at the University of Houston and the Women's Institute. Brauer has lectured and written extensively on American, French, and British modernism. Most recently Brauer has contributed a major catalogue essay for the exhibition *This Was Tomorrow, the Invention of Pop Art in Great Britain*, for the Kuntsmuseum in Wolfsburg, Germany, and an essay in the book *Derek Boshier: Rethink/ Re-entry*, edited by Paul Gorman (Thames Hudson, 2016).

Jim Edwards is an artist, contemporary art curator, and art writer. He received both his bachelor of fine art and master of fine art degrees from the San Francisco Art Institute and is a Rockefeller Fellow in Museum Education and Community Studies awarded through the Fine Arts Museums of San Francisco. Edwards has had a long-term and successful career as curator and gallery director at numerous art museums and universities throughout Texas and the American Southwest and is currently on the faculty at Houston Baptist University. He has also worked independently throughout his career as a curator and art writer.

Widely published, Edwards has primarily focused his writing on contemporary art in the American West. He authored an essay in the Martin Art Museum (Baylor University) publication *Texas Modern: The Rediscovery of Early Texas Abstraction* and wrote thirty-three artist profiles in *Texas Abstract: Modern/Contemporary* (Fresco Books, 2014). Edwards lives with his wife, Victoria Mikulewicz, in San Francisco and maintains a studio apartment in Houston.

Sarah Beth Wilson is curator of exhibitions and collections at the Art Museum of Southeast Texas (AMSET) in Beaumont. She received her bachelor of arts in art history and museum studies from Baylor University (2006) and completed her master of arts in art history at Texas Christian University (2009). Prior to her current position, Wilson worked at various art galleries in Houston and taught art history at Lone Star Community College. She currently serves as vice chair of the Board of Directors for CASETA and is an active member of the Texas Association of Museums (TAM). She is currently curating a retrospective exhibition on the art of Richard Stout, which will accompany this publication.

Mark Andrew White, PhD, is the Wylodean and Bill Saxon director of the Fred Jones Jr. Museum of Art in Norman, Oklahoma.

Linda J. Reaves, PhD, is a retired educator who, with her husband, has been an avid collector of Texas art for more than four decades. She is vice president and co-owner of William Reaves | Sarah Foltz Fine Art, where she serves as principal designer and editor of major print publications and is responsible for ongoing biographical research on artists associated with the gallery.

INDEX

NOTE: Page numbers in *italic* type denote photographs or images.